THE BEGINNER'S GUIDE TO
Landscape Painting

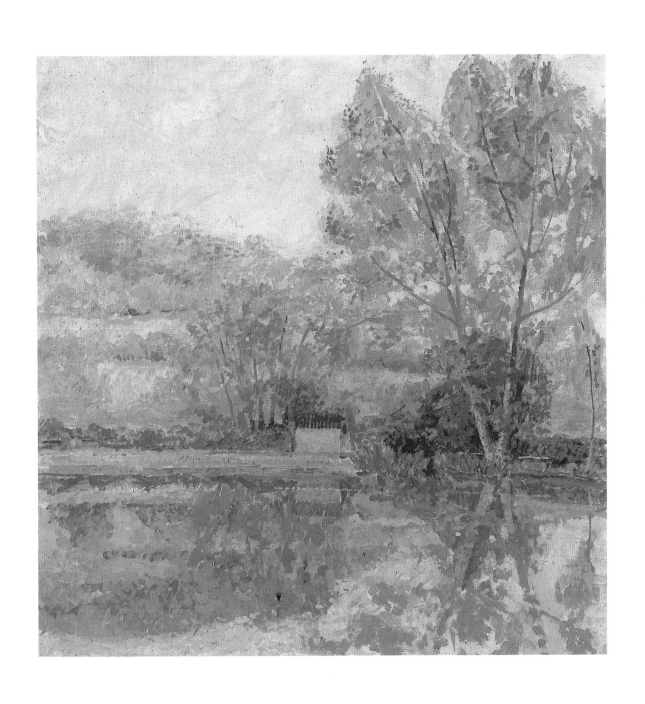

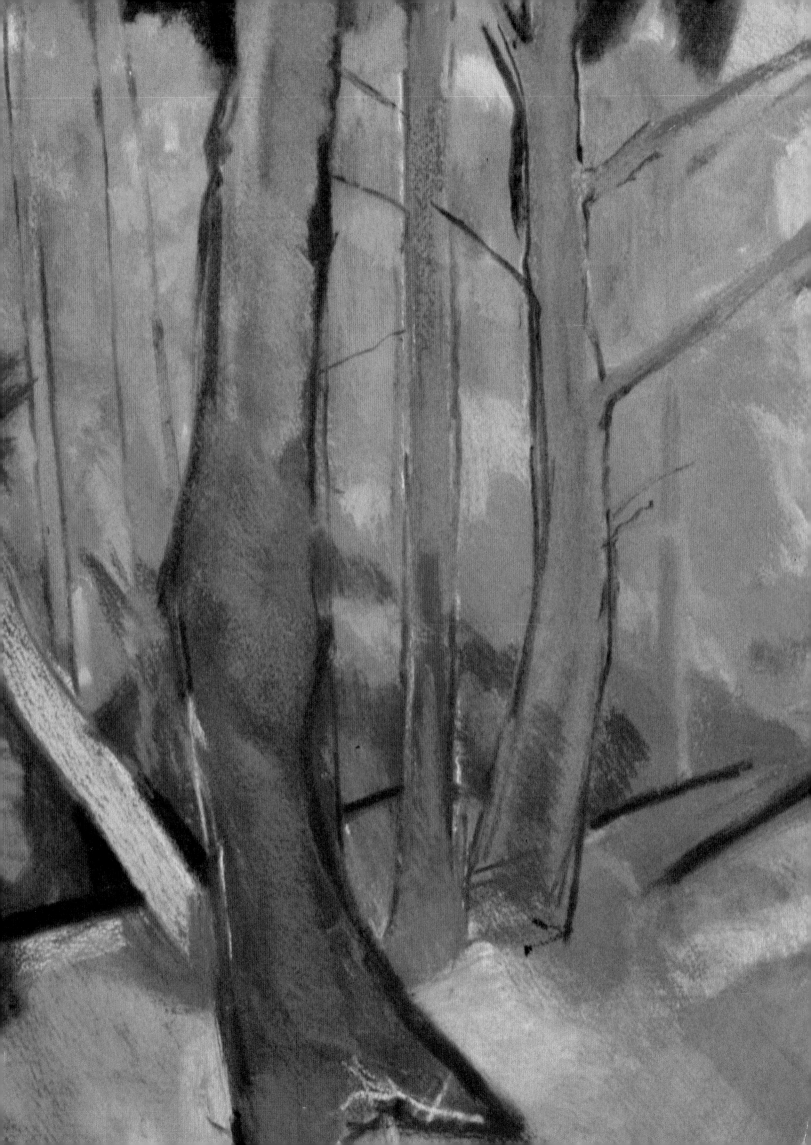

THE BEGINNER'S GUIDE TO
Landscape Painting

Kimm Stevens

CHARTWELL
BOOKS, INC.

Published by
CHARTWELL BOOKS, INC.
A Division of BOOK SALES, INC.
110 Enterprise Avenue
Secaucus, New Jersey 07094

Produced by
Brompton Books Corp.
15 Sherwood Place
Greenwich, CT 06830

ISBN 0-7858-0016-6

Printed in Hong Kong

PAGE 1
Peter Lloyd-Jones
Coombe Lake
Oil, 14 × 14 inches (35.8 × 35.8 cm)

PAGE 2-3
Kimm Stevens
Esher Common
Pastel, 21 × 30 inches (54 × 72 cm)

RIGHT
Kimm Stevens
Ullswater
Oil on canvas, 25 × 41 inches (64 × 105 cm)

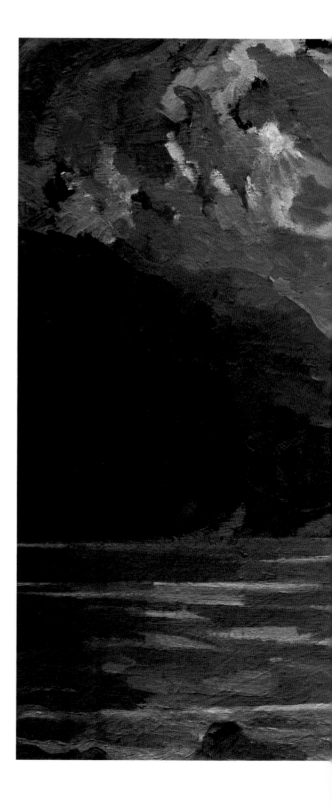

Contents

1. History

For centuries artists have been preoccupied with the desire to depict their surroundings. The images which they create inevitably derive from their immediate experience; whatever requirements their culture places upon them, be it the church, the state or the wealthy, they respond with imagery derived from their own experience and surroundings. This immediate response to nature brings an originality and freshness to painting which is common to all cultures, whether the image is an Egyptian tomb painting of a pond filled with fish and surrounded by ibis; a view of a fourteenth-century Flemish town glimpsed through a nativity scene; or a busy nineteenth-century Parisian street scene.

This spark of originality, the freshness of realism taken directly from nature, draws on common ground from generation to generation, and talks across the centuries far more effectively than the themes which the paintings are intended to depict. It is a fundamental justification for the existence and practice of landscape painting. Nature, animals, landscape and the human figure are common to all cultures.

The first true landscape – that is, a painting depicting nothing but landscape – appeared in seventeenth-century Holland. Prior to this, landscape was used as a background to the narration of a classical, mythological or religious story. In Botticelli's *La Primavera*, Flora strides out of an enchanted wood, flowers pouring from her mouth, bedecking the land with Spring. In Titian's fabulous *Bacchus and Ariadne* (pages 8-9), the reveling Bacchantae crash through the trees to meet Ariadne, who is looking out across a great sweeping coastline at her fleeing lover's boat disappearing over the horizon. In Campin's *Virgin and Child before a Fire Screen* (right), we see through the window an exquisite urban landscape of people going about their daily life.

By the seventeenth century, the landscape was beginning to dominate the painting and the subject and action became less significant. In Claude's *Landscape with Psyche outside the Palace of Cupid*, the figure of Psyche is dwarfed by the magnificence and enchantment of the landscape while in *Seaport and the Embarkation of Saint Ursula* the human drama is overshadowed by the superb light and atmosphere. Artists were using their painting of classical events as a vehicle to portray the more fundamental and expressive realism that nature and landscape offered.

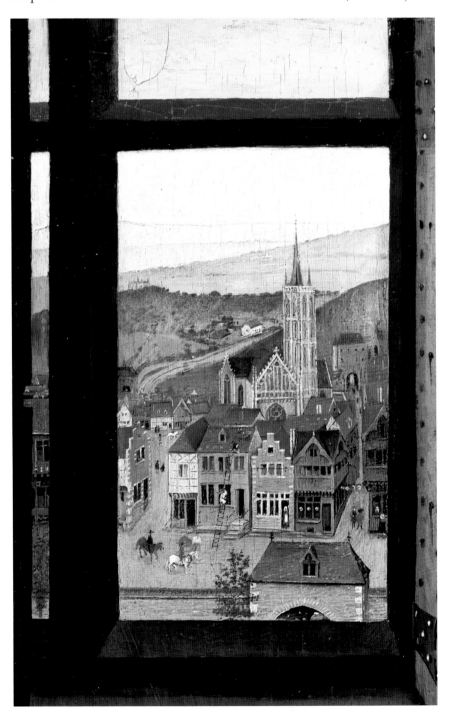

RIGHT
Robert Campin
Virgin and Child before a Firescreen, c.1430
Oil on wood, 25 × 19¼ inches (63.5 × 49.5 cm)
This domestic Flemish Nativity has a wonderful example of contemporary fourteenth-century urban life depicted through the window (detail below).

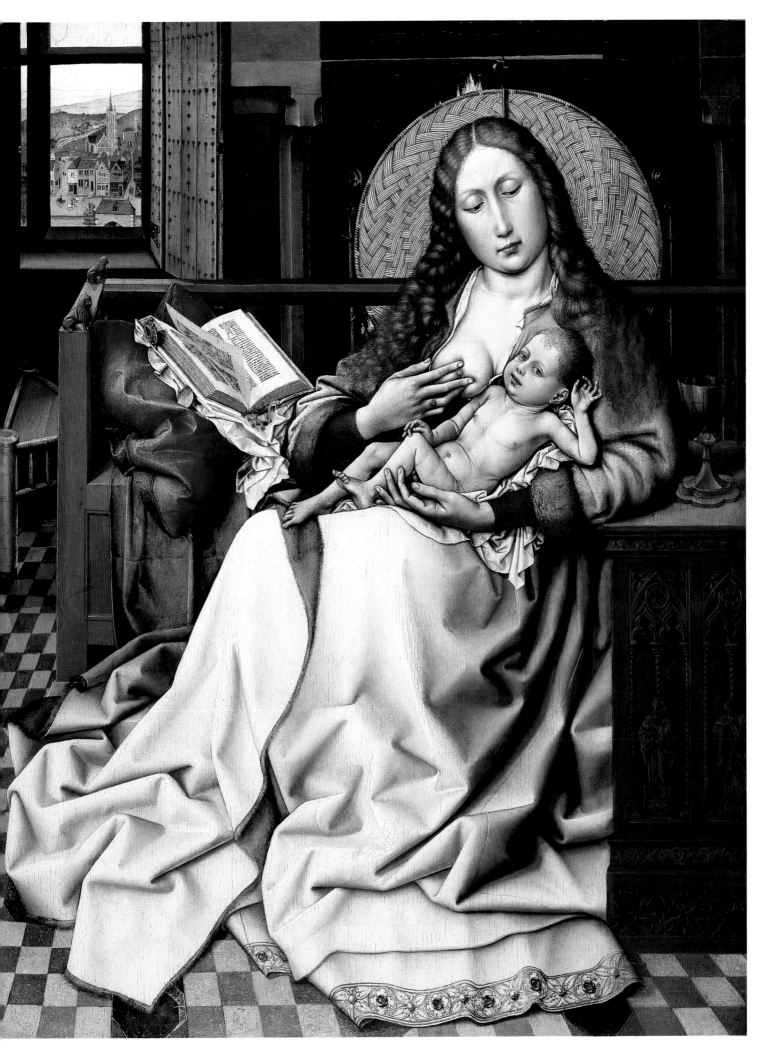

In the more puritanical and commercially-oriented society of seventeenth-century Holland, the concept of realism was accepted as a viable end in itself. The reformed church was strongly opposed to any iconography and the merchant classes wanted to celebrate power through wealth, both in property and land. It is in the seventeenth century, therefore, that landscape painting emerges as an individual genre: in France with the classical paintings of Poussin and Claude Lorraine; in Holland with the paintings of Ruysdael, Cuyp and Hobbema; and in Belgium, slightly earlier, with a small number of stunning paintings by Rubens. It was in Holland that artists began to paint the landscape as it was, deriving both composition and harmony directly from nature, with no allusion to the classical or mythological. In Hobbema's *The Avenue, Middelharnis* (pages 12-13), the use of direct observation and the geometrical harmony of the composition are as effective now, 300 years later, as they were at the time.

Rubens and his studio produced a staggering number of massively powerful Baroque paintings, but throughout his life he also painted portraits and paintings on a more personal level, to commemorate events in his life. One example is *Autumn Landscape with a View of Het Steen in the Early Morning* (page 14), his magnificent house and the land surrounding it bathed in early morning sunlight. The painting celebrates both Rubens' land and his life, and he takes great pleasure in detailing minutely the landscape he knows, but it is also a celebration of the magnificence of nature, the great sweeping vista, the blazing sunrise in a vaulting, cloud-filled sky.

By the eighteenth century the focus of landscape painting had moved across the Channel to Britain, where two main strands of topographical and romantic painting developed. Britain, geographically on the perimeter of European culture, had by then emerged as a major commercial, industrial and colonial power and was spreading her influence throughout the world. It was natural, therefore, that the educated and the aristocratic should make it an essential part of their education to embark on the Grand Tour of Europe, visiting the major cities and assimilating the modern and ancient artifacts of Italy and Greece. The cultural identity of Britain was enhanced by the return of these travelers, bringing with them work by artists such as Caneletto and Guardi, as well as Greek and Roman works.

RIGHT
Titian
Bacchus and Ariadne, 1522-23
Oil on canvas, 69 × 75 inches (173 × 191 cm)
This painting, with its theme of classical mythology, was executed as part of a series of paintings to decorate a room in the palace of Alfonso d'Este, at Ferrara, the others being painted by Giorgione and Giovanni Bellini. It is interesting that the decorative figures are rather frieze-like in appearance, flattened and rhythmic, while the landscape plays an enormous part in the painting, the clouds, trees, sky and sea all creating pattern. The space of the landscape is fully developed in its natural form, receding some considerable distance to the horizon.

OVERLEAF
Claude Lorraine
Landscape with Psyche outside the Palace of Cupid, 1664
Oil on canvas, 34¼ × 59½ inches (87 × 151 cm)
Unlike Titian's *Bacchus and Ariadne*, the mythological theme of this painting seems to be much less important than the romantic landscape, which is no mere backdrop to drama, but rather the main subject in which the drama unfolds. It is only a small step from here to painting a landscape for its own merits, rather than as a vehicle for some higher purpose.

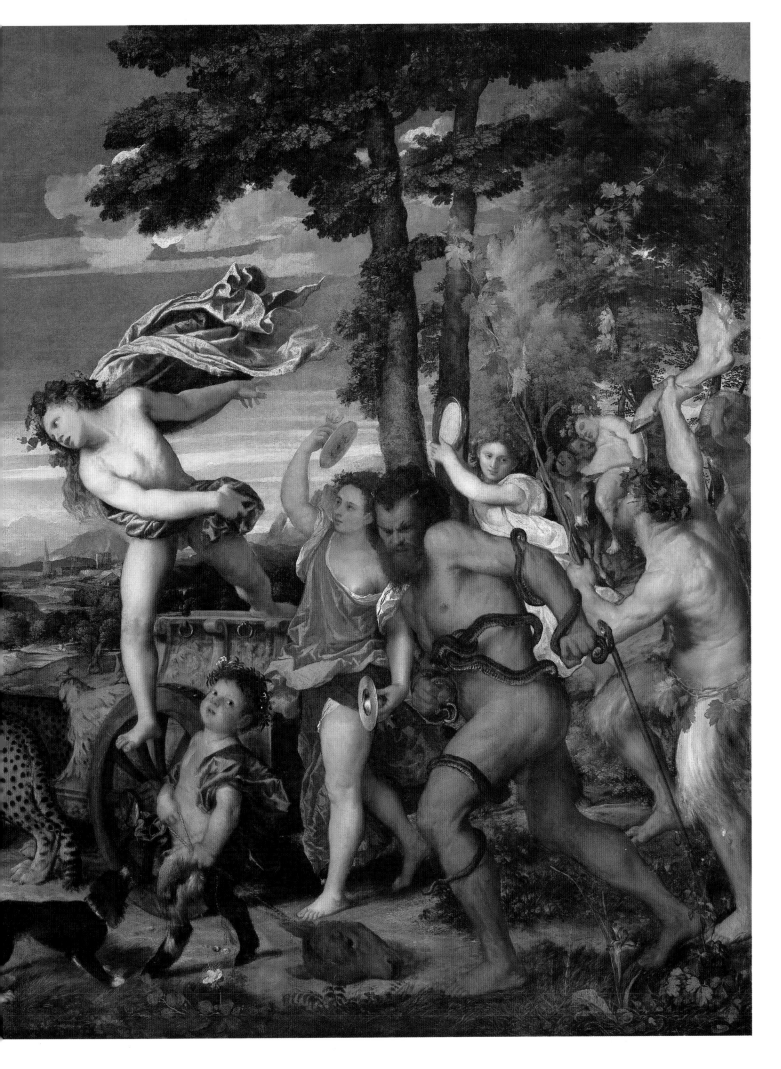

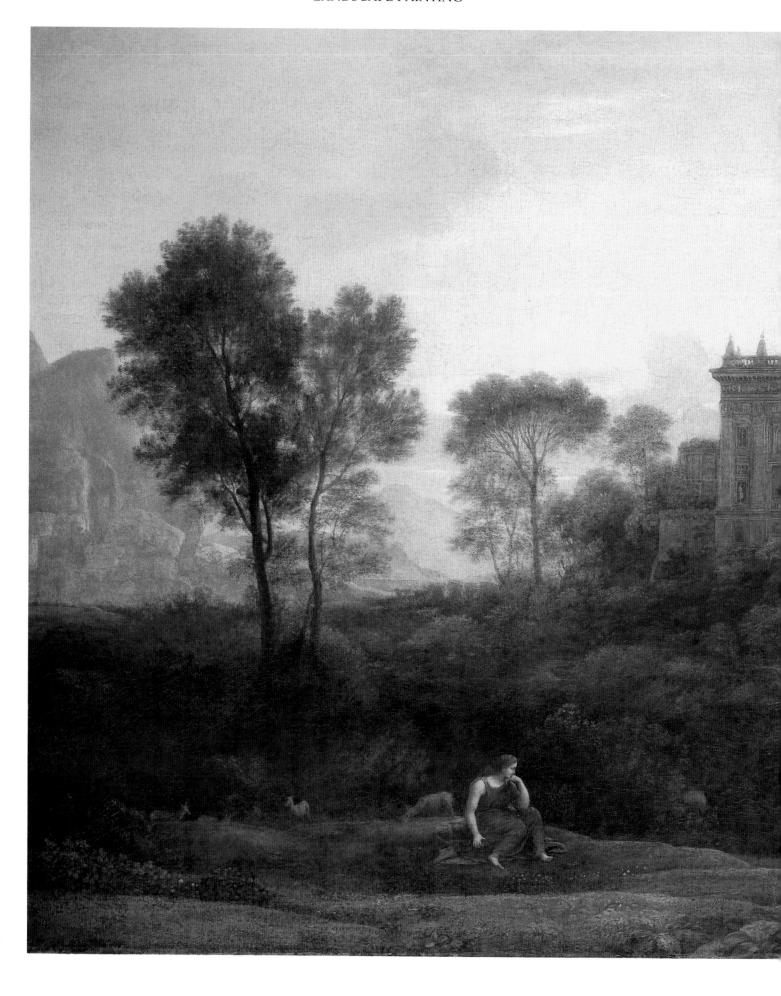

Meyndert Hobbema
The Avenue, Middelharnis,
1689
Oil on canvas, 40¾ × 55½
inches (104 × 141 cm)
One of the earliest pure
landscapes, depicting
everyday life in Holland,
this painting is dominated
by the pronounced single-
viewpoint perspective,
which creates a powerful
diagonal cross, forming the
basis of the composition.

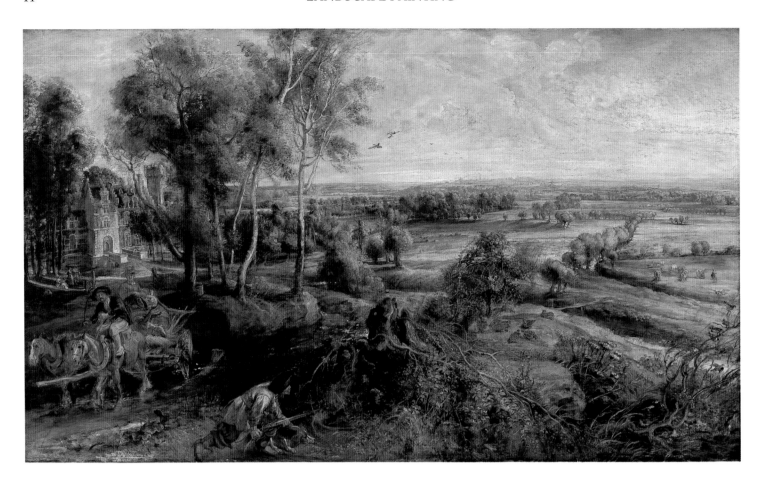

The grand tourists also recorded their experiences by using the light and convenient method of watercolor, rather as we would use the camera today. This provided Britain with a rich basis from which the tradition of both topographical and romantic landscape painting emerged. Interestingly, naval officers were also trained in the use of watercolor so that they could record the topography of the New World, which was being opened up to trade and conquest. Of the two strands of landscape painting, objective topographical studies, freshly painted in watercolor, found maturity in the Norwich School with the work of John Sell Cotman and Paul Sandby; the more romantic, dramatic approach was represented by artists such as Richard Wilson, who applied the Italianate classical style of Lorraine and Poussin to the rugged landscapes of the Lake District and Wales.

The two traditions of Grand Tour watercolors and romantic landscape combined and erupted in an explosion of creative genius with the work of Joseph William Mallord Turner (1775-1851). Turner, a great traveler throughout Europe, recorded his journeys in a mass of watercolors and sketchbooks, producing endless studies of light, atmospheric effects, landscapes and seascapes. He captured and exploited the drama of sunlight through direct observa-tion and experience, which he combined with a romantic appreciation of the power and excitement of the natural elements. His work acts as a pivot in landscape painting between the eighteenth-century classicizing tradition following Lorraine, and the more romantic and realist painters that follow.

The other great protagonist of British landscape painting during this period was John Constable. He is in some ways an even more revolutionary and influential painter; his achievement was to observe and record, without pretension or posturing, the Suffolk landscape in which he was brought up. He took the rich cacophony of rain and wind, clouds and trees, and people about their daily work on the River Stour, and held them in a harmonious and deceptively natural composition, painted with an economy that is nonetheless vibrant in detail and incident. Both his modest realism and his novel painting technique, rendering form and space with direct, positive brush strokes of paint, and fragmenting and frac-turing images into color and light, was to have a major influence on the development of landscape painting later in the nineteenth century.

At much the same time that Constable was rendering his love of the Suffolk countryside into paint, a group of painters in post-revolutionary France were developing

ABOVE
Peter Paul Rubens
An Autumn Landscape with a View of Hetsteen in the Early Morning, 1636
Oil on wood, 51⅝ × 90¼ inches (131 × 229 cm)
This glorious painting not only represents but celebrates the beauty and drama that the landscape offers. It forms one of the inspirational images behind the Romantic Movement, which found and exploited the drama in nature two centuries later. Research suggests that the canvas was added to over a considerable period of time, starting off as a modest study of the house and then developing into the fabulous painting we see today.

RIGHT
J M W Turner
The Dogano, San Giorgio Maggiore, 1842
Though primarily concerned with light in his paintings, Turner did not, as might be expected, have a great influence on Impressionism. The light in Turner's paintings has a heroic mystical significance which pervades the whole painting; it is as if the sun is creation itself and the scene portrayed, whether mythical or topographical, is all soaked in this sublime light.

their own form of realism, a realism infused with political idealism for the future rather than poetic yearnings for the past. Millet's *Gleaners* (pages 16-17), a fabulous glowing painting of evening light, shows us the poorest members of the agricultural community scrabbling in the stubble for the last morsels of the harvest while, in the distance, the more prosperous take the year's bounty home. Both Corot and Boudin painted outdoors like Constable but, unlike him, they recognized the value of these *'plein-air'* paintings and were prepared to exhibit them, whereas Constable would work up a studio composition for exhibition.

Plein-air painting, made more convenient by the growing availability of ready-prepared paints in tubes, enabled painters to record nature and the effects of light more swiftly and accurately, and with a more immediate and spontaneous realism. This development led to Impressionism, perhaps the most revolutionary movement in art since the Renaissance, which focused above all on landscape painting and took the realistic depiction of nature as its main subject.

The Impressionists were the first group of artists successfully to suggest that minor everyday events were adequate subjects in

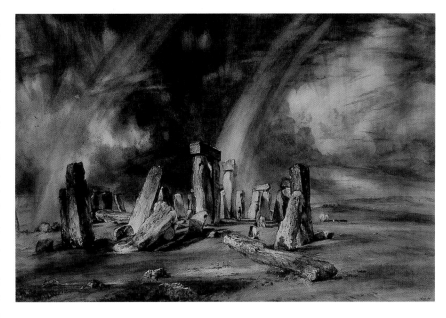

themselves. They did not use their paintings as vehicles for moral or political judgments but painted the world as they saw it. They used new ideas of color and light to show space and form, depicting the world not as the Academies had taught people to see it, but as the individual eye observed it. Color was to be the revolutionary development in Impressionism; hitherto, tone and color had played an important but secondary role in the establishment of space and form. With

ABOVE
John Constable
Stonehenge, 1835
Watercolor
This watercolor combines the vigor and freshness of observed nature with a clear sense of composition and geometry, producing a painting which is naturalistic, yet loaded with romantic import.

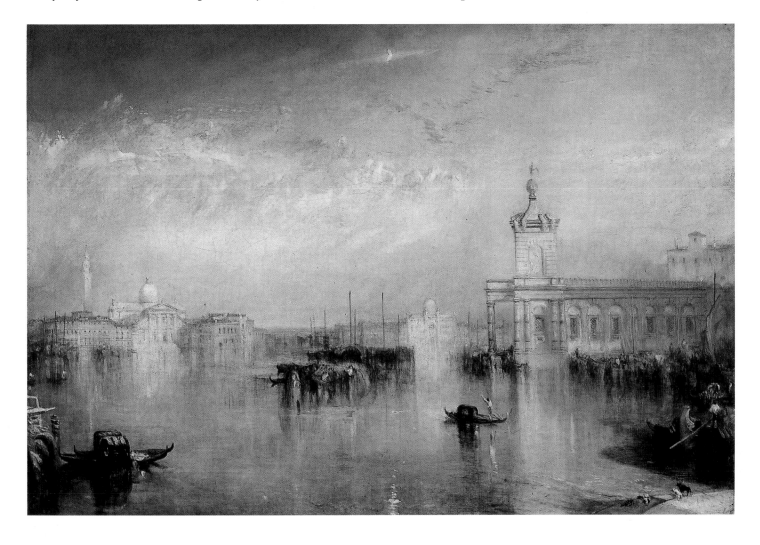

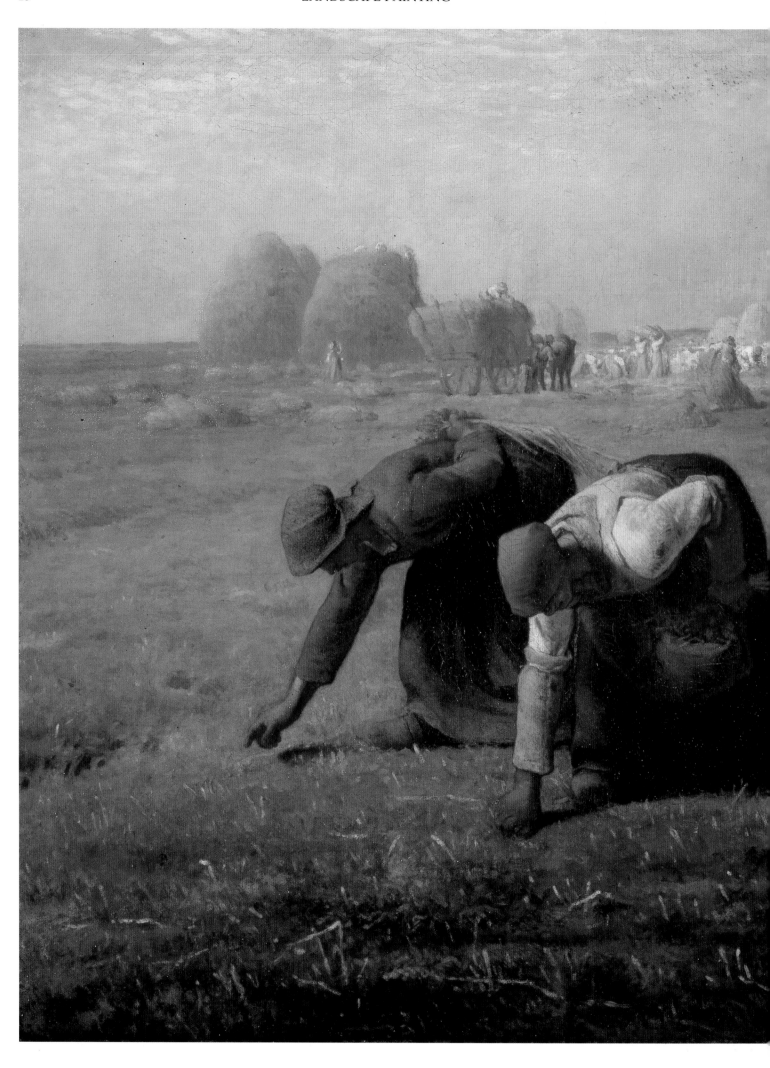

Jean-Francois Millet
The Gleaners
Oil on canvas, 32½ × 43¼
inches (83.5 × 111cm)
The drama of light and
color still exists in this
landscape, but the romantic
ideals that are present in
Rubens, Constable and
Turner are tempered with
the harsher realism of
poverty, represented by the
women gleaning the last of
the harvest for their
survival.

the growing understanding of the scientific basis of light, and the increased range of colors available as an offshoot of the chemical and dyeing industries, color became the principal tool for expressing space and light.

The Impressionists, while embracing the full range of subject matter, recognized landscape painting as the key to exploring the possibilities and harmonies of color and form. They exploited the recently discovered fact that color was not inherent in an object, but the result of the way light was reflected from it, and thus subject to constant change and modification. At first the movement was mocked; one critic wrote in 1876: 'Someone should tell M Pissarro forcibly that trees are never violet, that the sky is never the color of fresh butter . . .' In Monet's deceptively simple painting *Regatta at Argenteuil*, we are presented with bold slashes of blue, orange and white paint, which combine to create a dazzling effect of water while maintaining the individual qualities of the colors. We are as aware of the paint and color as we are of the illusion that they create. This theme runs through all Monet's landscape work and manifests itself

in its full glory through his series of *Haystack* paintings and the superb compositions of waterlilies that he made at the end of his long life.

In Pissarro's *The Côte des Boeufs at L'Hermitage near Pointoise* (overleaf), the very dense and enclosed space of woodland thicket is established through color. The red roofs through the wood complement and break up the greens and browns of the trees so that, once again, what initially appears to be a mass of color suddenly opens up to be a fabulous illusion of space. The sense of being there, and exploring and working out where one is, is extraordinary. The Impressionists succeeded in identifying light and color as crucial in the depiction of their surroundings. Combined with the revolutionary idea that mundane, everyday events and landscapes were valid subjects for serious painting, this laid the foundation for the radical developments that formed the basis for the explosion in creative thinking that has overtaken us in the twentieth century. Landscape, once again, plays an important role in this development.

One painter who worked for a time with

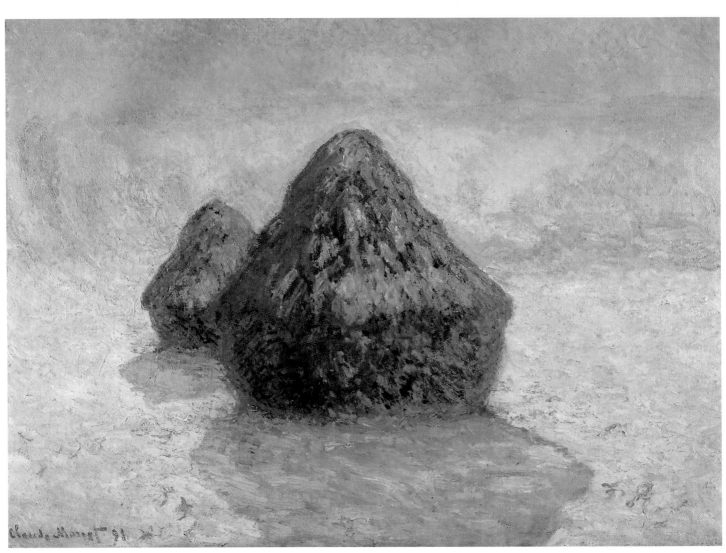

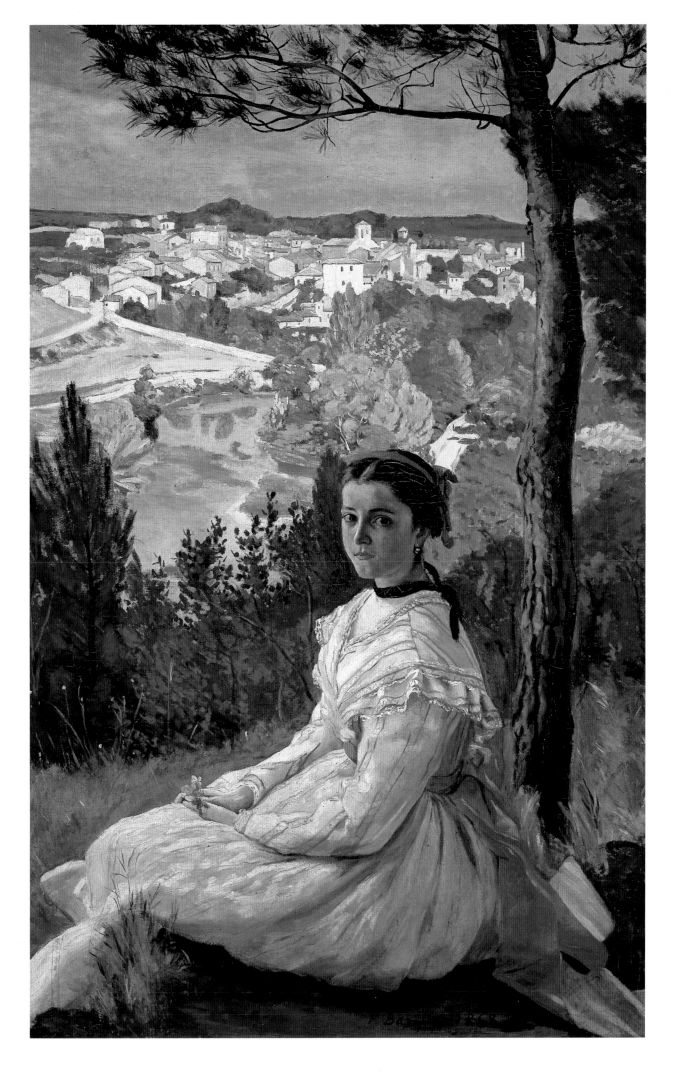

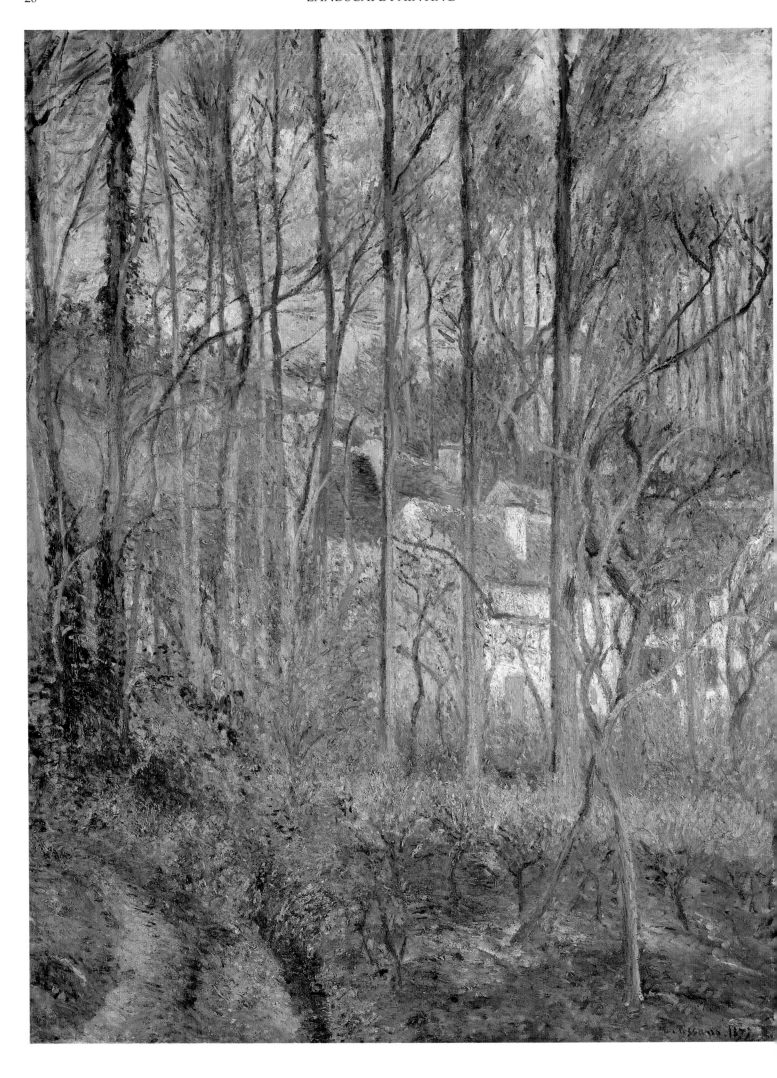

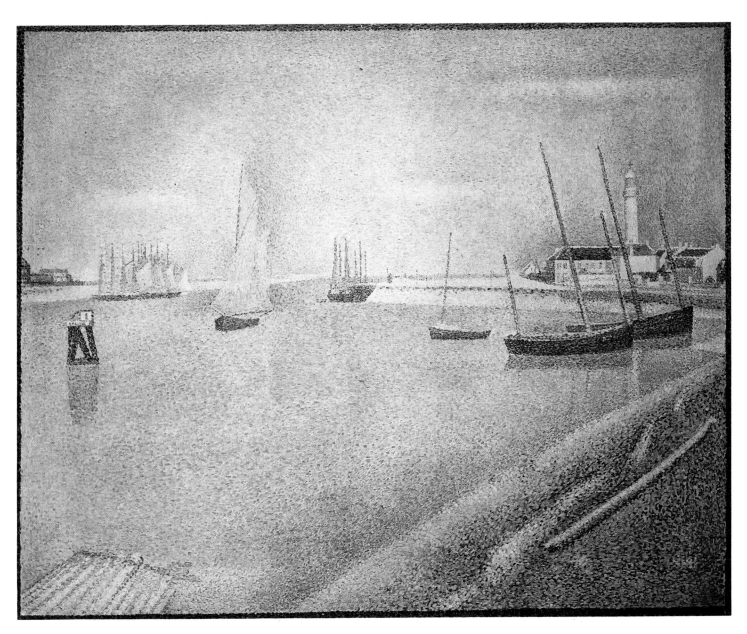

the Impressionists, Paul Cézanne, felt the need to counteract the inevitable dissolution of form and structure to which painting only in light and color led. He therefore resolved to give greater import and weight to Impressionism by reintroducing rhythm and geometric structure into the fragmented atmospheric color of his contemporaries. Where Monet dissolved form into light dashes of paint, Cézanne reasserted structure by establishing color as a facet of form. In Cézanne's painting, colors not only conveyed space and light but became an integral component of the painting, relating across the surface to one another, so that the painting is not so much an illusion as a harmony of marks that combine to present us with the concrete reality of the subject.

The revolutionary ideas regarding the use of color promulgated by the Impressionists were extended and formulated by Georges Seurat, who recognized the value of fragmented color in breaking up the surface of

the painting to give a sense of light and space. He created the system of painting known as Pointillism, using minute dots of pure color which merged to produce the image. The color he applied was pure and relatively unmixed and his painting achieved an incredible luminosity and brilliance. Like Cézanne, Seurat sought to give compositional order to the atmospheric, spontaneous *plein-air* paintings of the Impressionists. The combined effect of these revolutionary developments was to establish the primacy of form and color over subject matter as the fundamental and critical elements of a painting; landscape, with its ever-changing color, form and space, became a means to explore the possibilities and extremes to which a painting could be taken.

Cézanne had a profound influence on the early twentieth-century painters Braque and Picasso, who interpreted his ordering of space and form as a cue to abandon single-viewpoint perspective and reorganize the

FAR LEFT
Camille Pissarro
The Côte des Boeufs at L'Hermitage, near Pointoise, 1877
Oil on canvas, 45¼ × 34½ inches (115 × 87.6 cm)
The forms of houses and woodland trees emerge from the vibrant juxtaposition of warm and cool colors; the picture unfolds almost entirely through color, in a perfect fusion of paint surface and image.

ABOVE
Georges Seurat
The Canal at Gravelines, 1890
Oil on canvas, 28½ × 36¼ inches (73 × 93 cm)
Seurat extended and developed the color discoveries that the Impressionists made into a more formalized system, in order to achieve maximum luminosity. He applied the paint in small dots of pure color, which merged together in the eye to form the image.

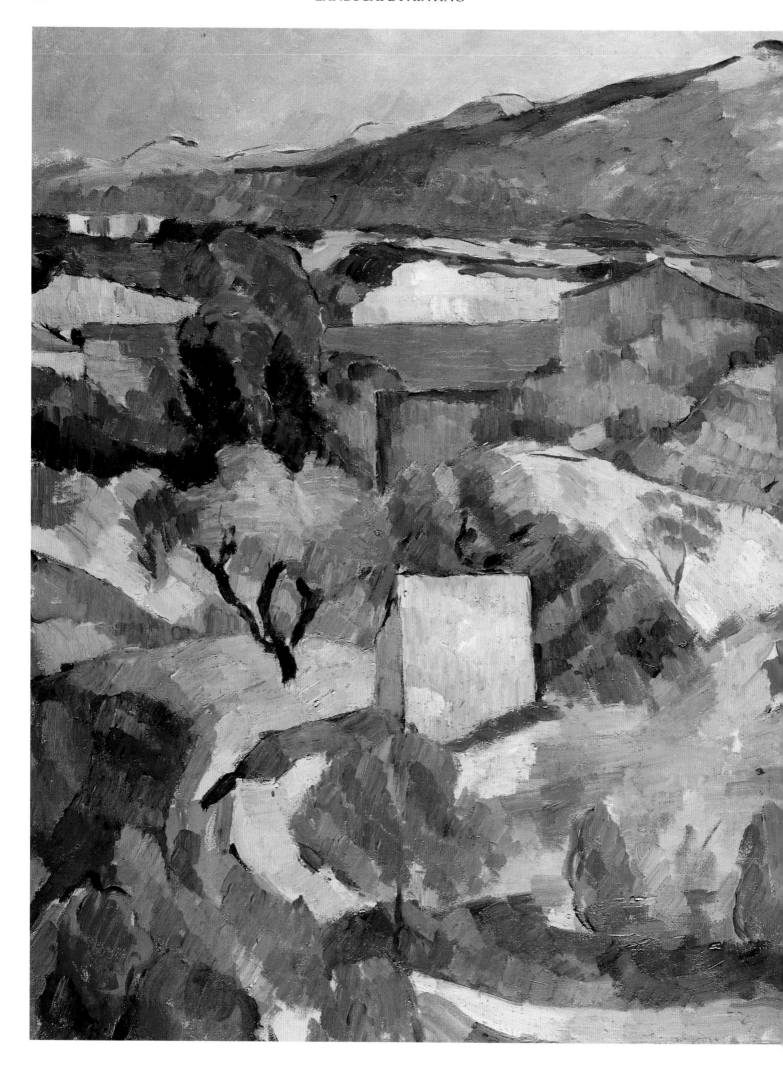

LEFT
Paul Cézanne
Mountains at l'Estaque,
1886-90
Oil on canvas, 21 × 28½
inches (54 × 73 cm)
Impressionist gestures and
delicate renditions of light
and form through color are
formalized and structured
to create these magnificent
compositions by Cézanne.
The structure and form is
not only linear, but extends
through to the use of color,
which is balanced between
red, yellow, green and
blue.

OVERLEAF
André Derain
Collioure, 1905
Oil on canvas, 28 × 35½
inches (72 × 91 cm)
Here form and space are
established almost entirely
through color. At first the
color seems over-
exaggerated, but it is
through this exaggeration
that the full range and
dynamic of color can be
exploited in order to show
space and form in such a
vibrant and exciting way.

canvas to combine multiple viewpoints. The first Cubist paintings, once again, were landscapes, although it must be said that the early Cubists quickly resorted to the more controlable 'landscape' of the still life.

At much the same time, Pointillist painters were using brighter and purer dabs of color, until the younger artists Matisse, Derain and Vlaminck broke out of this potentially stultifying mode and began to paint bold landscapes with the color pitched at its most extreme. Where shadows were subtly cool and blue, they were painted pure bright blue; where the trees were lit by the warm sunlight, they were painted orange and red: this, the Fauve movement, was perhaps the last revolutionary art movement to use landscape objectively. Although the colors were extreme and bright, they followed the fundamental natural harmonies presented by the landscape and were therefore true to the spirit of art following nature. The second generation of Expressionist painters, such as Nolde and Kokoschka, on the other hand, used landscape as a vehicle to express their own deepest feelings.

As the twentieth century progressed, artists became more concerned with personal expression and exploration, and landscape painting became less central to the main stream than it was in the nineteenth century. Nonetheless a considerable number of painters have turned to landscape as a source of inspiration and expression, including the English painters Nash, Sutherland and Piper, with their intensely realized visionary landscapes, and, in the latter years of the twentieth century, Francis Bacon with his desperately sad *Landscapes 1 and 2* and David Hockney's map-like excursions of color trails across California.

In this opening chapter, I have not only tried to describe the course of landscape painting over the past four centuries, but to convey the idea that, for every time and generation, landscape has been used for a different purpose, whether to express power and wealth in the eighteenth century, to charm the nineteenth-century industrialists, or to explore and extend the extremes to which a painting can be taken. Now, as we embark on the twenty-first century, horribly aware of the vulnerability of our environment, landscape as a subject once again becomes relevant: so much so, that artists like Richard Long literally bring great lumps of rock and earth into our galleries to remind us that out there the landscape is wonderful, powerful and full of endless possibilities.

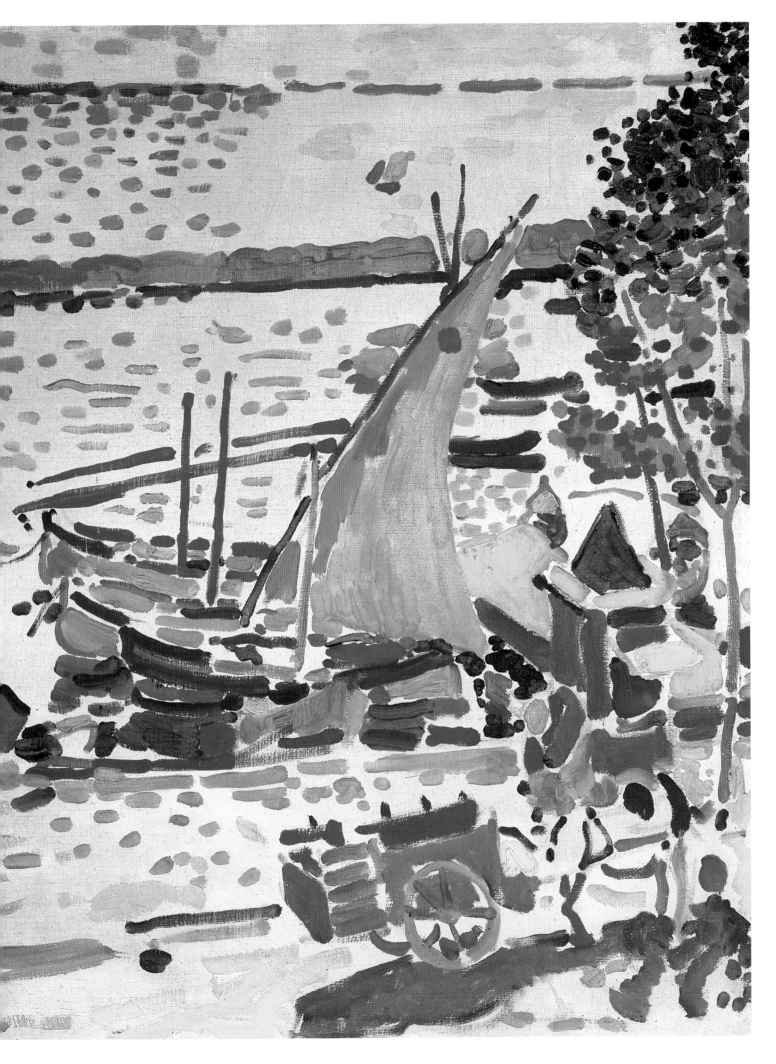

2. Equipment

Basics

When beginning to paint landscape, you need some equipment. This can be extremely rudimentary; I have on occasion been out walking without (dare I say it) any form of drawing equipment, and seen some wonderful effect of light crashing through trees and between buildings. I have had to resort to a ballpoint and the back of an old till receipt out of my pocket – not ideal equipment! – but I have noted down enough to jog my memory about the particular situation and then gone back to get more detailed information. The first things to have if you are interested in the landscape are a small pocket-sized sketchbook, a pen, soft pencil, sharpener and eraser. You should carry these around with you all the time, because you never know when you may see something that you want to paint, and if you are able to make even the briefest of sketches you will remember the idea you had and will be able to elaborate it later.

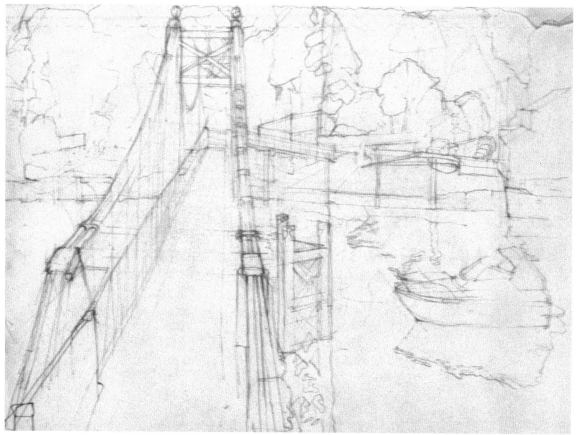

ABOVE LEFT
Soluble colored pencils combine the advantage of line with the opportunity to paint areas of color and tone. They allow you to make decisive and informative drawings quickly, with the minimum paraphernalia.

LEFT
This pencil sketchbook drawing of a bridge proved very useful as a basis for several studio pastel paintings. By completing a careful measured drawing, one gains considerable understanding of the structure and topography of the view, which helps to sustain more ambitious work away from the subject.

LEFT
A good, comprehensive
sketching set needs to have
its own bag and to consist
of the following equipment:
Sketchbook
Watercolor paper block
2b and 3b pencils
Eraser
Putty rubber
Colored pencils (preferably
water-soluble)
Retractable knife
Portable watercolor set with
water holder and supply
Watercolor brushes in
protective tubes, or
collapsible field brushes in
a selection of sizes.
Charcoal is another useful
drawing medium to carry,
but you must also have
some form of fixative
available to prevent the
drawing smudging.

Water-Soluble Pencils

The idea for the painting is the most elusive thing and must be caught on the instant. Pocket-sized equipment can most easily be extended to embrace color by including colored pencils. A small set of ten can be carried discreetly in pocket or bag and gives you much more flexibility and variety in sketching. A further refinement can be to have water-soluble colored pencils, which can be dissolved and brushed out on the paper to make color wash drawings. For this

you will need a folding brush, and the paper in your sketch book must be sturdy enough to be made wet. The main problem with water-soluble pencils is that you need a small supply of water to use them, though it is amazing how you can improvise. I hesitate to advocate the use of spit but it does work! A more effective (and hygienic) solution is to carry a small plastic screw-top medicine bottle, either already filled or to be filled on site; water often features in landscapes so you can use the river, pond or lake (or puddle) as a supply.

Watercolors

The next piece of equipment that is extremely useful, and enables you to make complete paintings, is a set of watercolors. Watercolors come either in pans or tubes. The pans need to be kept in a purpose-built box which usually has a built-in palette and space to keep a brush. The tubes can be kept loose, but obviously you will need some kind of palette (see page 32) for mixing your paints. Pans are very convenient and light and are particularly useful for fieldwork because the set is self-contained. Some sets come complete with their own water bottle and container.

Tubes enable you to mix greater quantities of color more quickly for large washes, although they are more bulky to carry. With watercolors you need specific paper, because the technique uses the white of the paper as the source of light and the rough texture to promote richness of color and tone (see page 39). A small block of watercolor paper should therefore be included in the set. It would still be possible to carry all this equipment fairly discreetly in various pockets or a large handbag, but it is becoming sufficiently bulky to warrant a specially designed art bag.

Brushes

For watercolor you will need some sable brushes or good quality synthetic versions; the brush hairs should be springy and bounce back into shape when wet. The hairs

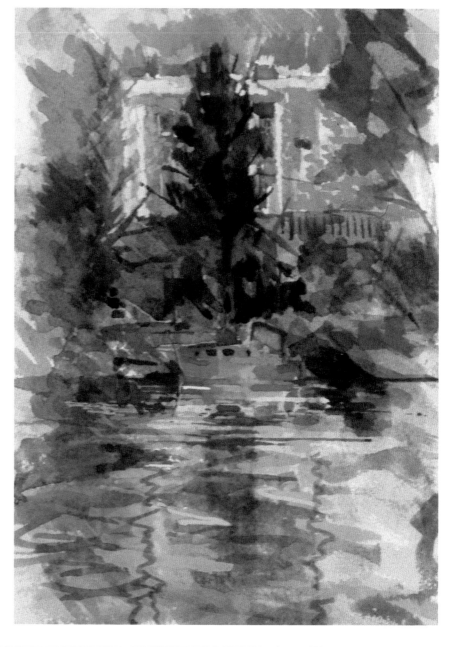

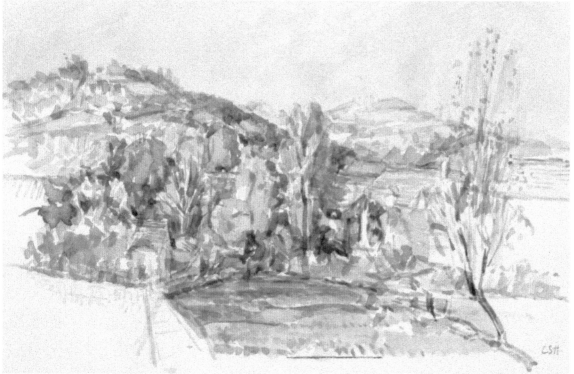

ABOVE
A selection of pages from various sketchbooks is shown above and on pages 29 and 30. Some sketches collect information, or stand on their own, others are a more intuitive response to the landscape and serve as a trigger for the memory. Both approaches are valuable, and both should be pursued.

LEFT
Clova Stuart-Hamilton
Autumn, Rueyres
Watercolor, 4½ × 8 inches (11.5 × 20.5 cm)
This approach to watercolor builds up the picture in small brushstrokes, producing a homogenous image. Each brushstroke is of a pure color, which prevents the watercolor from becoming muddy and maintains a clarity and lightness of touch.

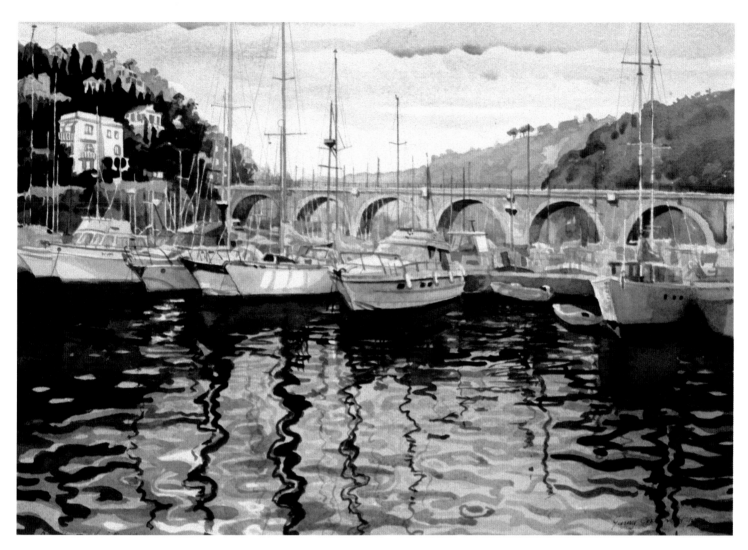

of a round brush, even a large one, should come to a pointed tip. Sable brushes are expensive but will last many years if you clean them regularly and thoroughly. Cheap brushes can prove a false economy.

Round brushes are the most versatile as they can lay in broad washes or produce a delicate line at the tip. Flat brushes produce block-like marks which can be very useful for building up form and bringing washes to sharply defined edges in a crisp and decisive manner. Brushes are very vulnerable and should be kept in a ridged plastic tube to protect the hairs; field brushes retract into the handle when not in use, thus protecting the hairs. These are very useful, although they can occasionally retract while you are painting, which is a little disconcerting!

Watercolor brushes come in different sizes from 000 (very small) right up to 16 (really big). Most beginners instinctively go for smaller brushes, as they seem to offer more control, but the larger the brush the more paint it holds, so you do not have to keep returning to the palette to replenish your brush. If it is a good brush, it will come to a point so that it will be possible to do delicate and intricate work even with a larger

size, so be bold: go for a larger brush size than you think is necessary. Of course, the final choice rests with your own inclinations and approach, and for extremely intricate work, the smaller brushes are essential.

Ginny Chalcraft
La Rague, South of France
Watercolor, 9½ × 13½ inches (24.3 × 34.5 cm)
This painting shows a strong decisive approach to watercolor painting; the artist has placed the paint in well-defined areas of tone and color, which builds up the image across the page. The result is both crisp and controled, enabling the very fluid medium of watercolor to convey a considerable amount of information.

LEFT
This sketchbook study of a palm tree was a spur-of-the-moment creation.

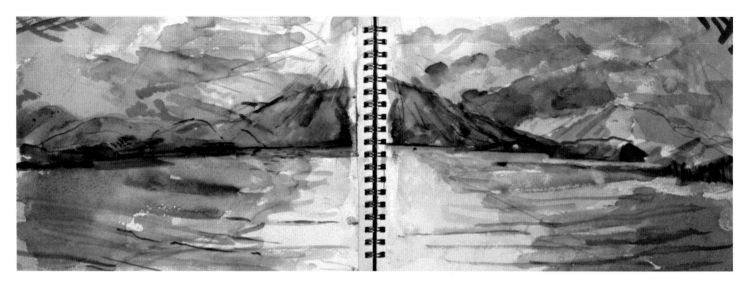

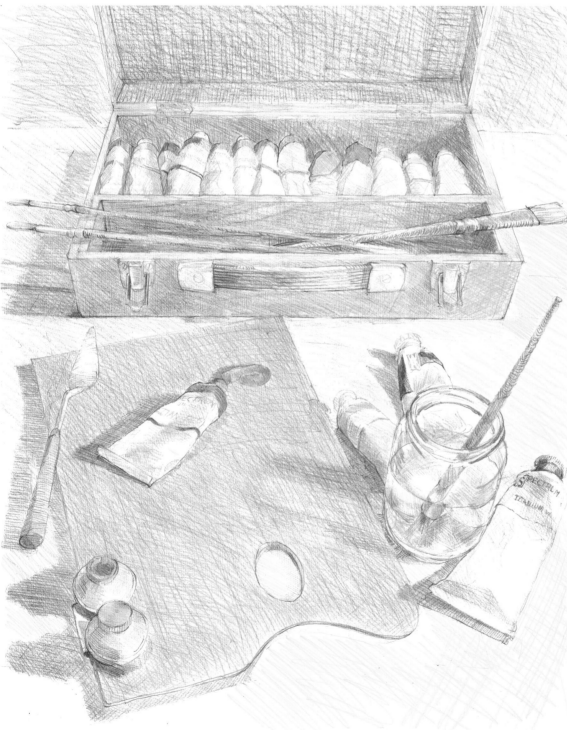

ABOVE
Sketchbook study.

LEFT
A basic set of oil paints, suitable for field work, should comprise the following:
Paint box
Tubes of the oil colors titanium white, lemon yellow, cadmium yellow, cadmium red, crimson, magenta, ultramarine, cobalt blue and cerulean blue (if you wish to paint with a lower key palette, include venetian red, yellow ocher, burnt sienna, raw umber, burnt umber and terre verte)
Palette
Jar of white/mineral spirit
Double screw-top dipper filled with pure linseed oil and turpentine
Set of bristle brushes sizes 4, 6, 8 and 10, both flat and round
Palette knife
Rags
Sketching easel.

FAR RIGHT
These two charts show a practicable layout of color on the palette, and the colors that offer the most flexibility and range in mixing. The first consists of a version of each saturated primary: white, lemon yellow, cadmium yellow, cadmium red, magenta, ultramarine blue, cobalt blue and cerulean blue. The second is a more subdued and subtle range of earth colors: white, lemon yellow, yellow ocher, venetian red, rose madder, burnt sienna, raw umber, burnt umber, ultramarine, cobalt blue and prussian blue. The color of the palette should be the same as that of the board you are painting on, so that you can judge how the color will work as you mix it.

Another very useful item for watercolor work is a small piece of natural sponge, which is good for wetting the paper prior to making a wash and also for laying on large washes of color. Other useful things for the art sketching bag are blotting paper, a sharp retractible knife and a water pot. Your sketching set is now fairly comprehensive, but still compact. Having a set like this with you means that you can efficiently achieve a comprehensive and sophisticated result wherever you are.

Oil Paints

Oil painting offers great flexibility, richness and power, and so is a very exciting way to paint the landscape. It is more bulky than watercolor, however, and potentially very messy because it takes a long time to dry, so you have to be fairly well organized.

The first thing you really do need for oil painting is a small sketching easel. Watercolor needs to be painted fairly flat, to avoid drips running down the paper, and so can be done on a small scale on your lap. Oil, however, can be painted in the plane you are looking in, which if you are standing up is vertical. It is therefore more convenient to hold your painting in the same plane, so that you can constantly make comparisons between the painting and the subject. This is what an easel is for and it also has the advantage of leaving both hands free to hold brushes and palette. Avoid using the very brightly colored easels that are available on the market, as these can alter your perception of color in the landscape.

Colors

The colors you choose should give you the broadest range and flexibility, so that you can mix any color you want. Basically if you have the three primary colors, red, yellow and blue, plus white, you will be able to mix all the other colors from them. In practice you need several versions of each color. A practical range would include White, Lemon Yellow, Cadmium Yellow, Cadmium Red, Crimson, Ultramarine Blue, Cobalt Blue and Cerulean Blue; from this selection you will be able to mix most colors. It must be said, however, that this offers a very high key palette. Before about 1800, the only colors normally available were earth colors – brown, earth red, yellow ocher, etc – yet artists achieved bright colorful paintings by relating these lower-key colors brilliantly and getting the maximum contrast between

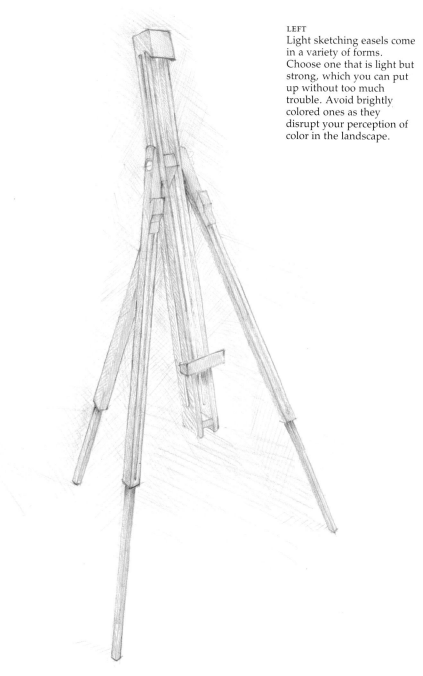

LEFT
Light sketching easels come in a variety of forms. Choose one that is light but strong, which you can put up without too much trouble. Avoid brightly colored ones as they disrupt your perception of color in the landscape.

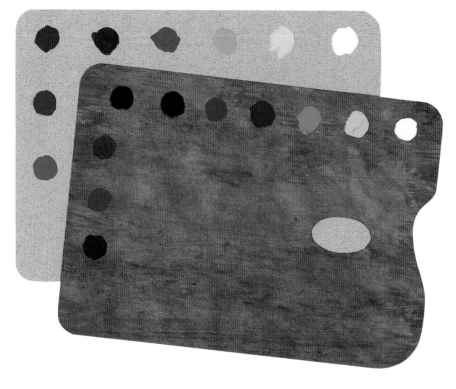

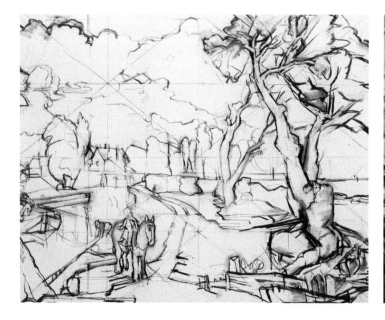

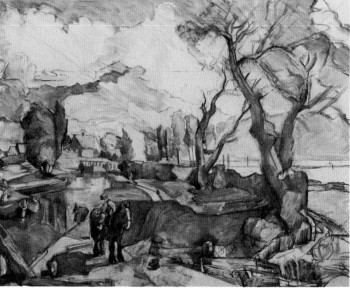

them. It is also possible to achieve more subtle, gentler results with a low key palette of White (Titanium), Lemon Yellow, Yellow Ocher, Venetian Red (Indian Red), Rose Madder, Raw Umber, Burnt Umber, Ultramarine Blue and Cobalt Blue. I generally recommend the higher-key palette because it offers more flexibility and makes the painter think about and work out the color that is actually needed.

Brushes

Brushes used for oil paint should be bristle or hog's hair, especially when you are painting with fairly thick, direct, impressionist brushstrokes, which is generally the most expedient way of painting *'plein air'* (out of doors). This is a stiffer, coarser hair than that used for watercolor and it holds the thicker oil paint more effectively. Applying paint with this type of brush leaves ridge marks, thus increasing the surface area of the dab of paint and making it appear a richer color. You should have a selection of different size brushes for small oil sketching, ranging from 4 to 10 in both round and flat types. Remember also to have several brushes of the same size, so that each can be loaded with a different color and used to produce the same type of mark in the painting without your having to keep cleaning out a favored brush.

Soft brushes are also used for oil paint, especially when painting in glazes. This is where fine translucent layers of oil paint are laid over one another, producing beautiful, subtle and rich effects. This method of oil painting is slower than the direct one, as each layer has to dry. It is not appropriate to *plein air* painting, which is normally done in one sitting, although it is worth having a small selection of soft sable-like brushes in

the paint box for making a greater variety of marks and for delicate brushwork. Oil paint brushes generally have long handles, enabling the painter to work at the easel from a certain distance. An arm's length plus brush length gives you a longer view of both painting and subject, so that you can see how the colors and tones are working together to produce the image. It is interesting to note that Thomas Gainsborough (1727-88), when painting his large studio portrait compositions, used 6-foot long brushes to enable him to stand back far enough to see the image whilst painting.

Palette and Palette Knife

A palette is essential for mixing colors. It should be a flat board with a thumb hole, to allow you to hold it securely in the crook of your arm. For outdoors, rectangular palettes are the most convenient, as they offer the largest surface area that will fit in a rect-

ABOVE AND RIGHT
Kimm Stevens
Flatford Mill after Constable
Oil on canvas, 40 × 50 inches (102.4 × 128 cm) This series shows the development from an exploratory line drawing, through scaling up and the laying down of a red tonal under-painting, to the full realization of color and detail in a copy of a formidable painting. The tonal monochrome stage is in red-earth (burnt sienna), which complements the cool greens and blues as they are placed upon it. Making such a copy is an extremely revealing and constructive exercise and is probably the best way to gain an insight into the way another artist works.

BELOW
Kimm Stevens
Tree 1
Oil on board, 10 × 14 inches (25.6 × 35.8 cm)

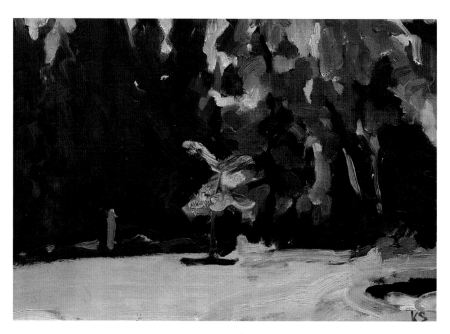

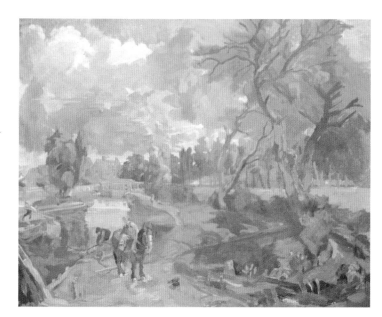

angular paintbox. Palettes do admittedly look a bit ostentatious and beginners can feel a little self-conscious when using one in public, but the design has been perfected over generations of artists and, for sheer convenience and efficiency in mixing colors, is hard to beat. A modern and economical variation on the basic palette is a tear-off greaseproof paper pad, which can be cleaned up by tearing of the soiled top sheet ready for the next session.

Palettes are available in white or a

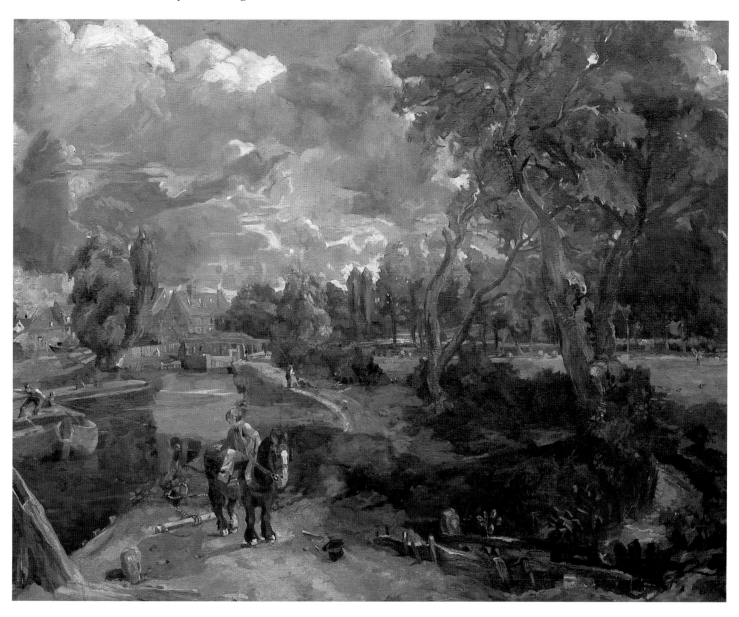

LEFT
Kimm Stevens
Norfolk Seascape
Oil on board, 10 × 14 inches
(25.6 × 35.8 cm)

BELOW
Geoff Humphreys
Cotswold Scarp
Oil on board, 15 × 18 inches
(38.4 × 46 cm)

RIGHT
This wonderful device
combines paintbox with
easel, and also provides a
means of carrying wet
pictures, a constant
problem when painting
landscapes. Its main
disadvantage is that it is a
bit heavy and may wobble
if the legs are made too
thin.

BELOW RIGHT
Geoff Humphreys
Morning Landscape
Oil on board, 15 × 18 inches
(38.4 × 46 cm)
This is painted on a red
ground, which sets up a
complementary relationship
with the greens that are
painted over it.

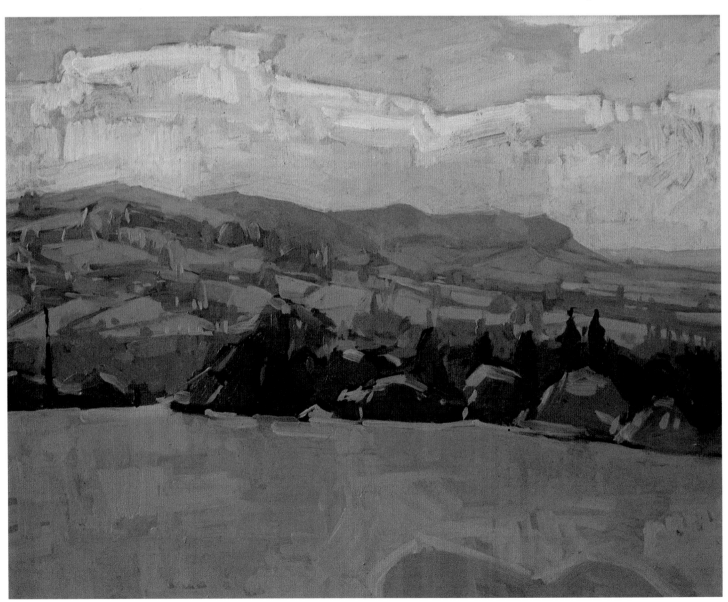

mahogany color; this is not purely an aesthetic choice, but relates to the colored ground (see page 30) on which you paint. Landscape painters often paint on a browny/red board, and a red mahogany palette enables you, as you mix the colors, to see how they will relate to each other in the painting. If you wish to work on a white ground, a white palette is more appropriate.

A palette knife is essential for mixing colors on the palette. These come in a variety of different shapes and sizes; I find that a smallish trowel-shape is very useful for fieldwork. A set of two screw-top dippers that clip to the palette offers a supply of medium (linseed oil) and solvent (turpentine or white/mineral spirit) to enable you to alter the consistency and flow of the paint while mixing. A jar with a tightly fitting screw-top lid, filled with white spirit for cleaning out brushes, and a soft cotton rag completes the basic equipment needed for oil painting.

Paintbox

All this equipment needs some kind of box to carry it in. The classic painting box is a wooden case about 14×18×3 inches, the most luxurious being lined with tin. Although these are a bit heavy, they are very convenient as they hold everything including the palette. Variations on this basic art box include those with devices attached to carry wet paintings, and very complex (and expensive) boxes combined with an easel, which unfolds to become a work surface, easel and paintbox all in one. A simple paintbox can be made cheaply at home with a minimum of carpentry skills.

Acrylic Paints

The other medium which is good for fieldwork is acrylic paint, which in some ways combines the positive, opaque properties of oil paint with the more delicate washes and glazes of watercolor. The basic set of colors needed is the same as for other media. The advantage of acrylic painting, but in some ways also the disadvantage, is that, being water-based, it dries quickly and is then waterproof, so a painting can be built up quickly in layers and changes can be made with ease. Delicate washes can be laid over thick impasto paint in a matter of minutes. Acrylic is particularly compatible with drawing materials and so acts as a robust bridge between the discipline of drawing and painting.

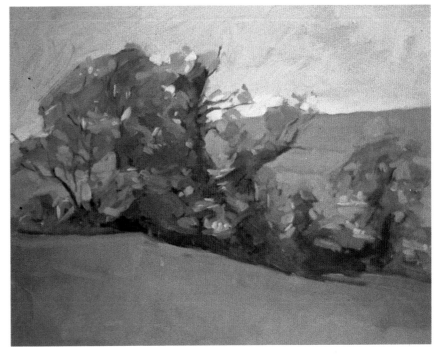

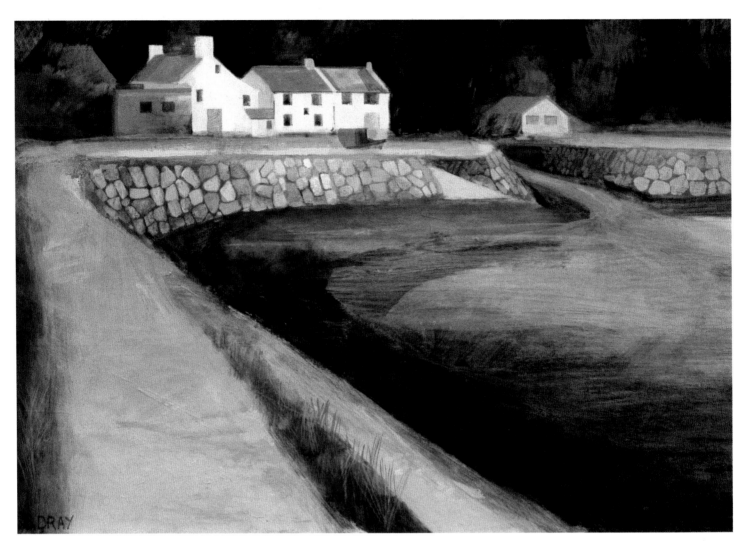

The basic equipment for acrylic painting is the same as for oil painting: you will need an easel and the same set of primary colors (see page 31). Because of acrylic's wide range of properties, brushes can either be bristle or the soft sable type, depending on the final consistency that you wish to achieve. I find a firm, synthetic, chisel-shaped brush is both positive and sensitive to acrylic paints and I would suggest that you include a variety of these in the paint set.

A word of caution about acrylic paint: because it dries so quickly, it is inevitable that the paintbrush gets clogged with dry paint around the ferule (the metal part of the brush in which the hairs are wedged), which tends to splay the hairs and renders the brush useless. This process can be delayed by keeping the brushes wet at all times while painting, and by scrupulously cleaning the brushes in detergent at the end of each session. Damage is inevitable, however, so do not use expensive sable brushes for acrylic painting; stay with the cheaper synthetic type.

The problem of acrylic paint drying so quickly, which is a particular headache on a hot day in the landscape, can be allayed in

two ways. The first is by adding a retardant to the colors as you mix them, which can be purchased in any art shop; the second is by mixing the colors on a special 'Sta Wet' palette, which is a plastic tray with a lid, containing wet blotting paper covered with a

ABOVE
Sally Dray
Dylan's Boathouse
Acrylic, 14 × 24 inches (35.8 × 61.4 cm)

special tissue, on to which you can mix your colors. When the tray is closed, it acts as a micro-climate and keeps the paint wet for several days. In the process of mixing, the paint draws moisture through the liner and stays wet. The specially prepared blotting paper liners and tissues can be obtained at art shops. If you prefer not to accumulate too much special equipment, any shallow suitably sized plastic box with a tight-fitting lid will serve as a substitute for the Sta wet palette.

Survival Equipment

In addition to the set of paints and drawing equipment, which should fit into a small backpack or paintbox, you will need to take into consideration other practicalities when you are out painting the landscape for long periods of time; even on quite warm days you can become cold when you are sitting or standing immobile for long periods of time. Equip yourself with sweaters, a raincoat and fingerless gloves. A hat with a wide brim is useful, both for keeping the rain off, and for shading your eyes from the sun and reducing glare, which can make painting on sultry days very tiring. Do not wear sunglasses, as these reduce the impact of colors and tonal values. A thermos of hot tea or coffee is an essential item as it keeps you both warm and sane when things start to go wrong.

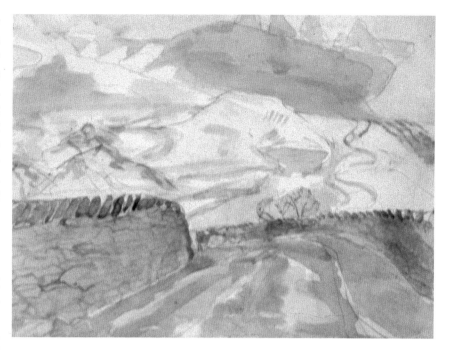

Landscape in the Studio

All the above items of equipment, although pared down to the basic minimum for field-work, are adequate for use in the studio (or kitchen table) at home. The beauty of working indoors from sketches made in the field is that you have time to consider what it was that excited you about the particular view, and then have the time and space to experiment with composition, color and media to achieve that idea. The biggest piece of equipment that you need at home is a space where

ABOVE
Sketchbook watercolor

LEFT
Kimm Stevens
Yorkshire Road
Pastel, 22 × 30 inches (56.3 × 76.8 cm)
The watercolor sketch above was done immediately after returning from an evening walk in the Pennines. The hills seemed to merge with the sky, snow and clouds being interchangeable; it was an exciting and powerful image of a hard landscape. The sketch was later developed into the pastel, where the physical gestures possible with charcoal emphasize the energy and the raw power that the landscape had on that cold, late winter's evening.

FAR LEFT
Sally Dray
Cornish Landscape
Acrylic, 16 × 20 inches (41 × 51 cm)
Acrylic paint can be built up in opaque areas, or in very fine washes. In Sally Dray's paintings, both approaches have been used. The surface of the painting is established with fairly firm, decisive passages, which have then been modified with washes and glazes to produce the final subtle effect. Acrylic dries flatter than oil so that the appearance is drier and less luminous, an effect that has value in its own right.

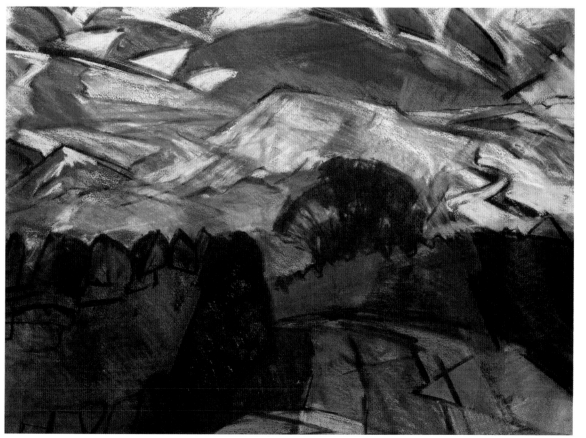

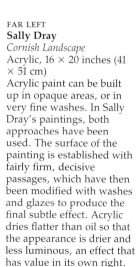

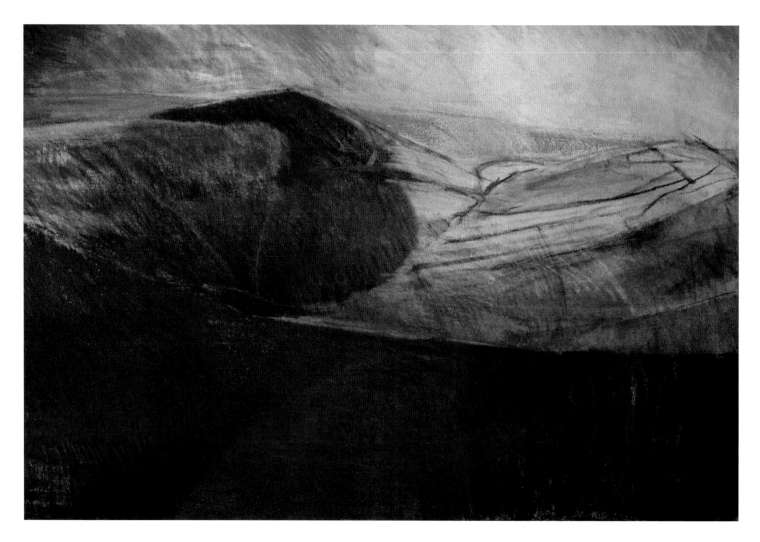

you can set your easel up without being disturbed every five minutes. If you are lucky, that will be a whole room but, even if it is only a tabletop or cupboard, try to allocate it exclusively to painting, so that you can quite easily leave your work out undisturbed, without the great effort of setting up each time. You will find that you will be able to make amazing progress on a painting even in short snatched moments of time, if you can arrange a work space in this way.

Pastels

The other medium that I want to discuss, and which is probably more conveniently used in the studio although it is quite feasible to use it outside, is chalk pastel. Pastels consist of pure pigment bound lightly with gum and rolled into sticks. As a medium, they offer the directness of drawing plus the color of painting. They can be mixed, by blending the colors together on the paper and by layering different colors on to each other, but it is vastly preferable to have as many different colors and tints readily available in the set. This is why pastel sets so quickly become quite large and unwieldy. You should have, as a basic set, warm and

cool versions of red, yellow, blue, green and purple. This gives you ten basic colors. Then you should have at least three to four tints – that is, progressively lighter versions of each color – thus making a set of 30 to 40 colors. Several sticks of white, for adjusting the tones on the paper, complete the set.

This set will give you a very wide range of color and tone, and enable you to make decisions about tones and colors by choosing the most appropriate pastel, rather than by mixing different shades haphazardly on the paper. A stiff bristle brush is used for manipulating the pigment dust around the paper, and fixative spray (aerosol or diffuser) is essential for preserving the drawing, as it is literally made up of particles of unbound pigment and should be given a light coating of fixative when finished. It is unhealthy to breathe in the dust from the pigment in pastels, so it is advisable to wear a lightweight mask, especially if you get a bit physical and excited when drawing.

Another type of pastel is oil pastel, which is pigment bound with an oily wax. The colors are limited and very crude, but beautiful effects and colors can be obtained if they are dissolved on the paper with white/mineral spirit.

ABOVE
Kimm Stevens
Mottistone Down
Pastel, 24 × 36 inches (61.4 × 92.2 cm)
Pastel drawings do not have to be light pale colors; make sure that you have saturated pastels in your set, as well as tints, and you can obtain a very full tonal as well as color range.

RIGHT
Kimm Stevens
Golden Gate
Pastel, 22 × 30 inches (56 × 76.8 cm)
By balancing warm and cool blues and grays of similar tints, you can build up a strong sense of space. Combining this with positive local color and perspective creates a bold drawing which conveys information by means of tone and color.

Grounds

The other crucial area of equipment is the surface on which you paint. This can be paper, board or canvas, depending on the type of work you wish to do.

Papers

Paper is available in a huge variety of textures and weights and it really is up to the individual to experiment and decide which suits their purposes best. In drawing, generally speaking, the smoother papers are good for line drawings, where a rough surface would blur the purity of the line. More textured papers are good for tonal work, especially charcoal and pastel. The textured paper abrades the charcoal or pastel stick, allowing it to transfer the pigment to the paper more efficiently, and a larger quantity of the pigment dust can be held in the ridges of the textured paper, thus producing richer colors and tones.

Pure watercolor requires fairly thick, rough, white paper. The white paper is integral to the painting as it acts as the light in the painting. Tones and colors are achieved

by laying thin glazes over one another which allow the white paper to glow through, thus giving luminosity to the painting. The paper needs to be rough (referred to in art shops as NOT as opposed to HP) so that it holds a satisfactory amount of pigment. The rougher the paper, the richer the colors can become. A fairly heavyweight paper of 140

ABOVE
Barge sketch.

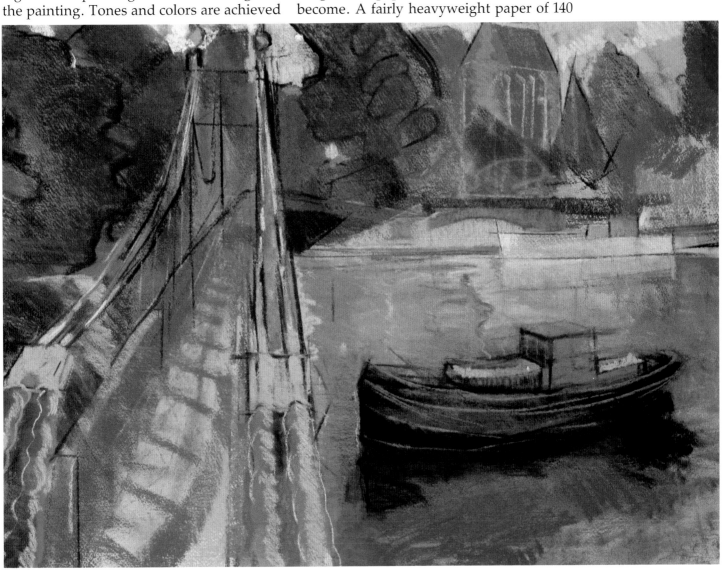

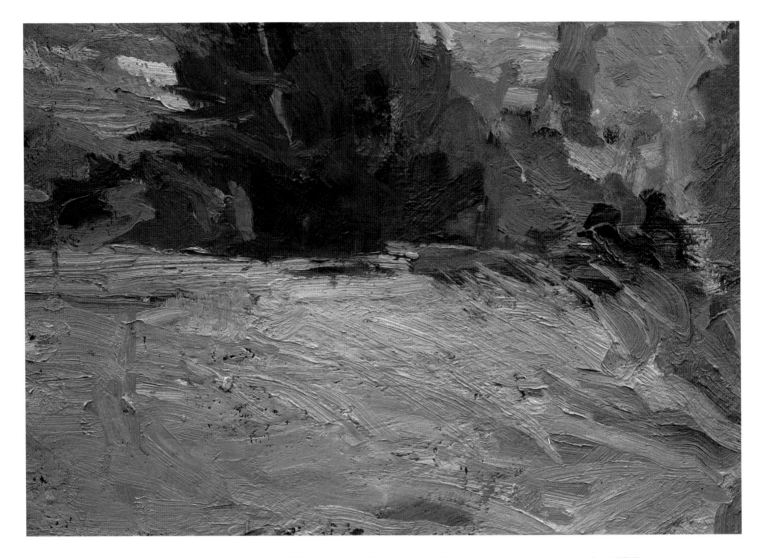

gsm is convenient for watercolor, as it will not buckle when it gets wet. Lighter papers can be used but they will have to be stretched. This is done by soaking the paper briefly in water, laying it flat on a drawing board and, while it is still wet, sticking it down all around the edges with two-inch brown paper tape, and allowing it to dry flat. The wet, swollen, paper shrinks as it dries out, so it tightens like a drum and becomes a totally flat surface to work on. Stretching is necessary for light watercolor paper and cartridge paper, and offers a good ground for both watercolors and acrylics.

Papers also come in different colors and tones, which are especially useful when using pastel as it allows you to judge the tonal value of the colors as you apply them. Once again be prepared to experiment, but a very effective use of colored grounds is to select the complementary to the prevailing color of the subject; for example, if the landscape is predominantly green, try drawing it on a warm, browny-red paper.

Boards

For oil paint and acrylic you need a more substantial surface, either a board or a stretched canvas. Simple, ready-prepared painting boards can be purchased fairly inexpensively from art shops and are perfectly adequate, though you should select 'canvas boards', which have muslin glued to the surface.

Hardboard is a very stable ground which can be cut to any size, but it must be thoroughly sealed to stop it absorbing the oil out of the paint. A good acrylic primer or dilute PVA glue is perfectly adequate for the job. Use the smooth side of the hardboard for painting on and avoid the machined textured side; being machined, it has an unremittingly mechanical surface which will dominate all the marks you make when painting. If you require a more textural surface, glue muslin on to the smooth side of the board with PVA, allow it to dry, then paint on two coats of white acrylic primer and you will achieve a beautiful working surface.

Larger boards (over 18 inches wide) need to be supported by a frame of 2×1 inch battening attached to the back. The joinery for this is fairly simple; use half lap joints or miters, or even butt joints reinforced by a plate at each corner. The board is then glued

ABOVE
Kimm Stevens
Windy Day
Oil on board, 10 × 14 inches (25.6 × 35.8 cm)
This was painted in a short time, the main aim being to capture the freshness of color and light. You can achieve a freshness of paint surface by painting so quickly, but you must concentrate hard in order to keep to the point and know to stop when you have shown what you intended.

RIGHT
Geoff Humphries
The Apple Tree
Oil on board, 18 × 24 inches (46 × 61.4 cm)

The process of stretching paper.

FAR LEFT
Prepare a clean drawing board, a sheet of watercolor paper, four pieces of two-inch gumstrip paper cut slightly longer than the paper edges, a bowl of water and a sponge.

LEFT
Wet the back of the paper evenly, using the sponge, and lay it face up on the board; the paper should bubble up slightly.

FAR LEFT
Damp the gumstrip by running it through the water or wiping it with the wet sponge.

LEFT
Tape all the edges of the dampened paper to the board and allow it to dry flat. The paper will stretch as it dries because it is anchored by the gumstrip. Leave it attached to the board as you paint and you will have a fine and stable surface on which to paint watercolors.

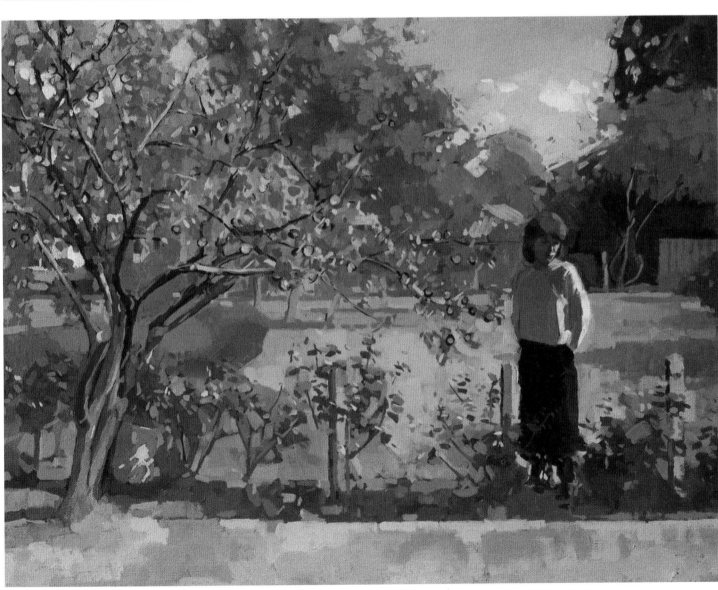

and nailed to the battens with hardboard nails, the nailheads being pushed below the surface and the holes filled, before you prime it with two to three coats of acrylic primer.

Canvas

The traditional ground for oil painting and still the most convenient, especially for large paintings, is canvas. Canvas was favored as a ground historically because it is relatively light and can be sewn together, so huge paintings are feasible. It can also be rolled, so transportation of huge paintings is easy. Canvas has a delightful texture to paint on and there are many different types and prices; once again you should experiment and choose the type that suits you best. Canvas is a fairly unstable surface to work on, however; being a woven material, it swells and shrinks due to humidity and weather. It dents, it rots and it is highly absorbent.

Canvas also needs careful preparation. Ideally it should be mounted on special inter-locking stretchers. A stretcher is a frame with specially-cut corner joints which can be opened by hammering wedges into the corners; this stretches the canvas and keeps it flat and taut. Ready-prepared, primed and stretched canvas can be purchased from art shops and this is obviously the most convenient, though most expensive, way to start. Canvas also needs to be carefully sealed and primed, to ensure that the oil paint cannot penetrate and rot the material. Two or three coats of proprietary acrylic primer does this job perfectly well.

The traditional method of preparing a canvas for oil painting involves, first, attaching the canvas to the stretcher, nailing down the center of one side, then the center of the opposite side, followed by the centers of the other two sides, while keeping the canvas under tension at all times. Work along each side toward the corners, maintaining an even strain across the stretcher. At the corners, make a folded tuck to ensure that there are no creases as the canvas turns, and make sure that the interlocking miter joint is not nailed together. Once the canvas is stretched, you should paint hot rabbit-skin glue size on both sides and allow it to dry, applying two further coats to the front of the canvas. The purpose of the rabbit-skin glue is to seal the canvas from any paint. Once this is dry, two coats of good-quality oil-based undercoat should be applied, to build up the surface and provide a sound base for painting. This is quite an arduous process,

but it is very satisfying to do and gives the best ground for an oil painting.

Camera

The final piece of equipment that is extremely useful for collecting information in the field is a camera. If the camera is used in conjunction with drawings and paintings, it becomes a valuable aid for gathering detailed material and provides a reference and reminder when working in the studio. I am not recommending that you use it as the main reference, for if you copy a photograph of a landscape, you will simply paint a picture of a photograph. Your drawings and paintings are the true key to your ideas and experiences and, ultimately, to your own originality, which should be more interesting than any photograph. The camera's value lies in providing a wealth of detail for reference, and it can freeze movement, which is extremely useful if you are drawing animals, or people on the move. Any camera will do, but the most universal is an SLR camera, preferably with a zoom lens, giving you greater flexibility in framing the picture that you want. Polaroid cameras are especially useful if you need to refer instantly to a photograph while drawing, to help you capture a fleeting moment or movement.

LEFT
Three simple joints for preparing corners when battening a hardboard panel.
(i) A simple butt joint, which is glued and strengthened by nailing a plate or triangle of hardboard across the back.
(ii) A miter, which is neater and can be nailed diagonally through the miter to prevent the joint opening up should it be twisted.
(iii) A half lap joint, which takes a little more time and measuring, but provides much more strength and rigidity to the panel, and is neater as it needs no reinforcement.
Once the frame is made, the hardboard is glued and nailed on to it, which makes the whole panel very rigid. The nails should be punched below the surface of the board and the holes filled. The edges should be sanded or planed so they are flush with the battening and then the whole board should be lightly sanded, ready for priming.

ABOVE RIGHT
Kimm Stevens
Standing Stone
Charcoal, 22 × 30 inches (56.3 × 76.8 cm)
When making an ambitious drawing on site, you have all the information in front of you to select from and can distill the experience of the place while you are there.

RIGHT
Jim Lee
Landscape with Greenhouse
Oil on board, 24 × 36 inches (61.4 × 92.1 cm)
Built on a strong diagonal, this picture carries the eye up and across the canvas, to be stopped by the end of the field, which forces the eye down the tree to the left and back up the diagonal thrust of the greenhouse.

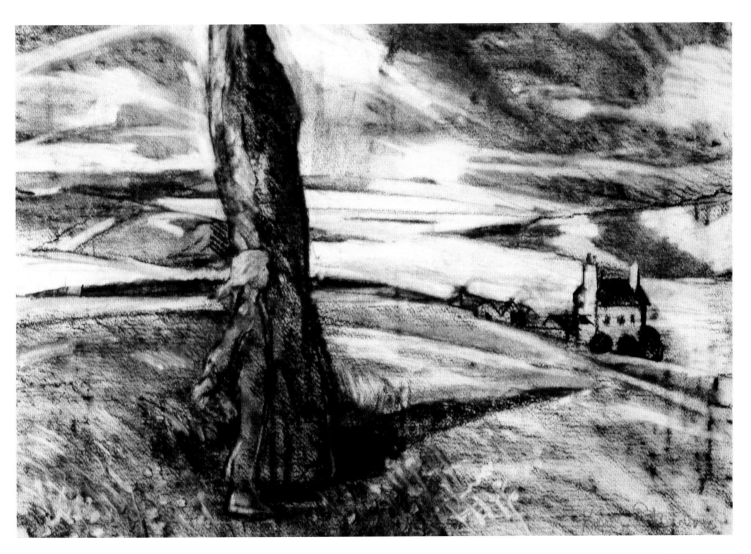

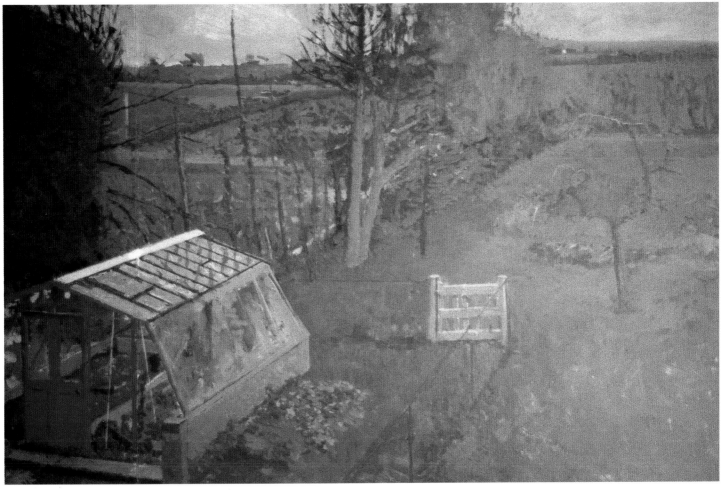

3. Drawing

Drawing is the action of making a mark on paper; various marks create a pattern, which can be harmonious or discordant. The totally magical thing about drawing is that the marks which combine to make pattern and rhythm can be organized so as to fool the brain into thinking that it is looking at something that is not there. It can create an illusion of reality. Show any person a picture of a vase of flowers and they will say 'It's a vase of flowers'; but it isn't, it's a load of paint smeared very cleverly on a piece of canvas.

This trick, this illusion, has been developed, discussed, changed, formalized over the entire history of civilization, with different cultures developing different methods and systems. The artist can absorb these systems and can use them as the basic mechanics of creating illusion in drawing. In the twentieth century, painters have looked to many cultures and developed new drawing systems, but the most fundamental and powerful system of creating an illusion of reality, and the most common in Western civilization, is perspective drawing.

Perspective

Perspective is a geometric system which takes account of the fact that objects appear to diminish in size as they get further away,

and that the eye level of the viewer coincides with the point at which the objects recede to nothing. In its simplest form, the sides of the top of a cube, seen head on, will recede to a point that coincides with the viewer's eye level. You can demonstrate this to yourself by performing a simple exercise. Sit directly in front of a rectangular object, say a table,

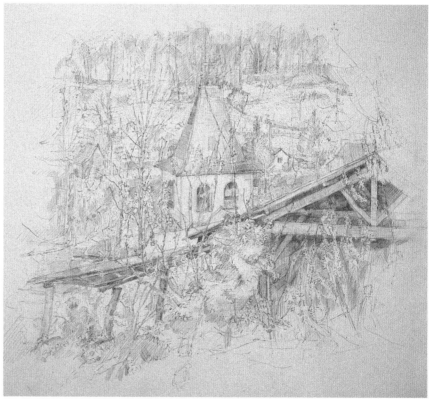

BELOW
Clova Stuart-Hamilton
Houses, Rueyres
Pencil, 14 × 14 inches (35.8 × 35.8 cm)
Sensitive use of pencil establishes the eye-level and perspective of the buildings, and provides the contrasts between foliage and building structures.

look straight ahead through one eye and locate a point on the wall opposite which is in direct horizontal alignment with your eye. Do this by placing a sharp pencil very close to your eyeball so that you can see the point as you look ahead. Make a mark on the wall where that point comes; this point is the center of your vision. It should be exactly the same height from the ground as your eye is if you are sitting up straight. Now take two long pencils and with one in each hand hold them vertical and very close to your face, keeping one eye shut, adjust the pencils, keeping them vertical, so that they run up the sides of the table. The pencils should form two sides of a triangle whose apex co-incides with the mark you made on the wall. Any other line in the room that is parallel to the sides of the table, say a skirting board or the corner of the ceiling, will also extend up or down to this point. Try it and see! If you stand up and perform the same exercise, the lines will recede to a new higher horizon that again coincides with the height your eye is from the ground. This demonstrates basic single-point perspective and the critical relationship between horizon and eye level.

Obviously we do not see the world conveniently from a head-on view, so a more useful development from the basic single-viewpoint perspective is two-point perspective, allowing an object to be presented at an angle to the viewer. The basic criteria still apply; each side of the object recedes in different directions, and lines that are parallel to each other in real life recede to the vanishing point. All lines recede to the same level, the horizon. Again, if the eye level changes, so do the angles of recession. This has huge implications in landscape painting because it enables you to establish different senses of space, be it a crowded urban scene or a great open vista seen from a mountain top.

There is a third element of perspective which occurs in very large objects, such as buildings, which is that they recede both

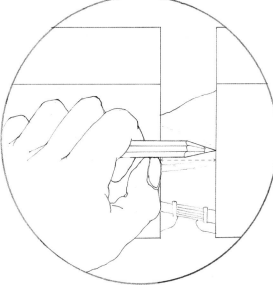

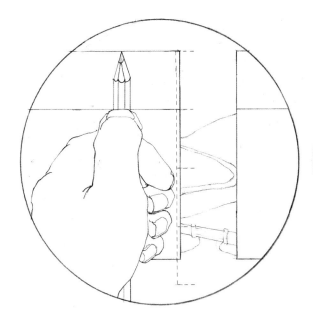

ABOVE
Kimm Stevens
Backyard I
Charcoal, 30 × 22 inches
(76.8 × 56.5 cm)

LEFT
Holding the pencil at arm's length, measure off a chosen dimension, using the point of the pencil and the thumb, and see how many times that distance goes into another dimension in the view; in this case, the gap between the two buildings is compared with the height of the building on the left.

FAR LEFT
Ginny Chalcraft
Cumbrian Stream
Conté and pastel, 11½ × 32¼ inches (29.4 × 82.5 cm)
This drawing uses line to build up textures and tones simultaneously into a delightful study of trees and water.

from side to side and upward or downward. This is known as three-point perspective and reflects the fact that the viewer is looking up at an angle rather than dead ahead, where all the vertical lines are parallel.

A grasp of these basic elements of perspective will enable you to understand and anticipate how certain lines help to create a feeling of space and volume. The angles of lines in the landscape become crucial and often relate to the horizon and the viewer's eye level. Direct observation is the critical element of landscape painting; to gain a sense of space you need to develop ways of making sure that you are drawing what you

see rather than what you think you see. This objective approach gives you control, greater understanding of what you are looking at and, ultimately, greater freedom to express your ideas with originality, because you have collected the information first-hand from nature itself.

Scale and Space

One of the most surprising things in the landscape is how dramatically scale changes as the distance increases and how often we alter that scale, depending on what importance we place on particular features. If you

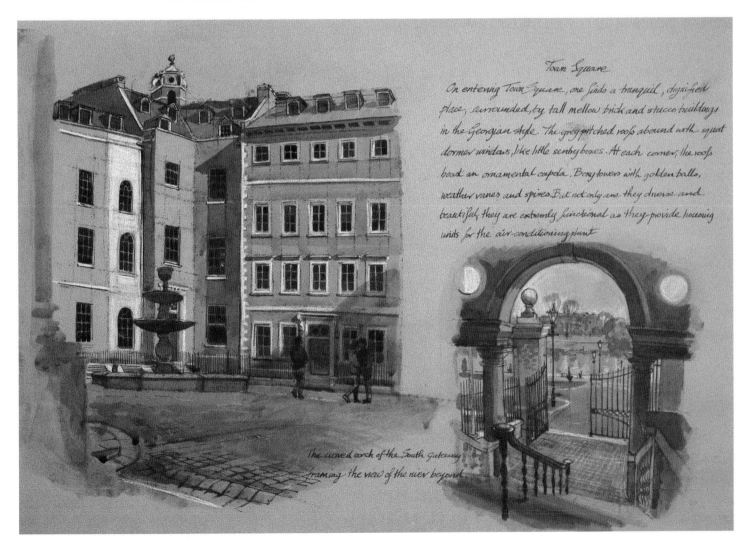

Town Square

On entering Town Square, one finds a tranquil, dignified place, surrounded by tall mellow brick and stucco buildings in the Georgian style. The grey pitched roofs abound with squat dormer windows, like little sentry boxes. At each corner, the roofs bowd an ornamental cupola. Boxy towers with golden balls, weather vanes and spires. But not only are they diverse and beautiful, they are extremely functional as they provide housing units for the air-conditioning plant.

The curved arch of the South Gateway framing the view of the river beyond

are impressed by a certain building or natural feature, it is very easy to emphasize its importance by making it too big in the picture. While there is nothing intrinsically wrong in doing this – indeed many cultures use scale to emphasize importance – the effect of it is to destroy the sense of space within the picture, which may foil your original intentions. A sense of scale can be maintained by constantly measuring and comparing the dimensions of different features and shapes within the landscape itself.

The very simplest and most direct way of seeing and drawing the actual scale of the subject is to trace a view on to a piece of glass. Take a felt-tip pen and stand at a window looking out. Close one eye and, keeping your head very still, trace on the glass all the lines and shapes that you can see. Do not worry what each line is, just trace them all. You should, in a very short time, have made a drawing that has a very strong sense of space and scale. When doing this, see how small, near objects, say a leaf on a nearby plant, compare in scale to distant, large objects, like buildings or cars. Often what

we perceive as small turns out to be comparatively much bigger than what logic tells us we should accept as large. Not only does this exercise demonstrate the radical changes of scale that exist between objects over different distances, but it also forces you to translate the three-dimensional space of reality into a two-dimensional illusion on a pane of glass, by drawing space and objects as a series of flat shapes that fit together like a jigsaw puzzle.

Once this idea has been grasped, it is a small step to making a drawing. Seeing objects as shapes enables you to depict them as they actually are and not as you think they are. Seeing shapes also enables you to appreciate the relationships and spaces between objects, so that you are no longer looking at objects which float around in a void, but are looking at the relationships between the objects and the space that they occupy. The drawing rebuilds the specific momentary reality that presents itself, and you have a wonderful opportunity to capture and fix the harmony and beauty of those relationships, which are unique and totally original.

ABOVE LEFT
Try looking at the landscape, not as separate trees and buildings, but as the shapes that those objects make between each other. If the photograph represents the basic landscape, the outline of the shapes between the trees emphasizes the particular relationships between them and creates a drawing that is both confident and original.

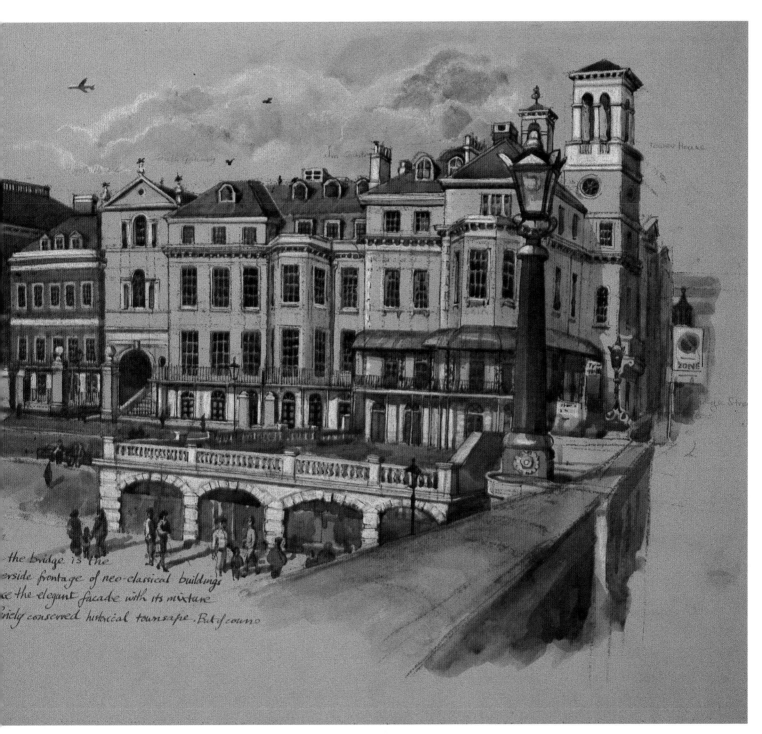

the bridge is the
rside frontage of neo-classical buildings
e the elegant facade with its mixture
iely conserved historical townscape. But if course

Measuring

There are several methods and devices to help you see the shapes you are observing as they actually are, and drawing on glass is an extremely good demonstration. Accurate measuring also helps you to check your decisions and is a very simple procedure. I suggest that you draw first, then check your initial, instinctive response, rather than measuring it all up first, which can make the drawing rather mechanical. To measure, take a pencil and hold it out at arm's length vertically, parallel to the plane of your face. Select a shape from the view that you wish to investigate, say the proportion of the gap between two buildings. Now, taking the pencil

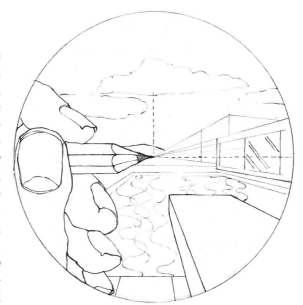

ABOVE
Ginny Chalcraft
The Riverside
Pen and wash with gouache, 14 × 21 inches (36 × 54 cm)
Strong linear perspective and dramatic contrasts of scale create a powerful statement about the neo-classical architecture of Richmond, Surrey.

LEFT
Hold the point of the pencil close to one eye, with the other eye closed, so that it appears in the center of your vision. The point will coincide with the horizon and your eye-level, and marks the level to which all parallel lines will recede.

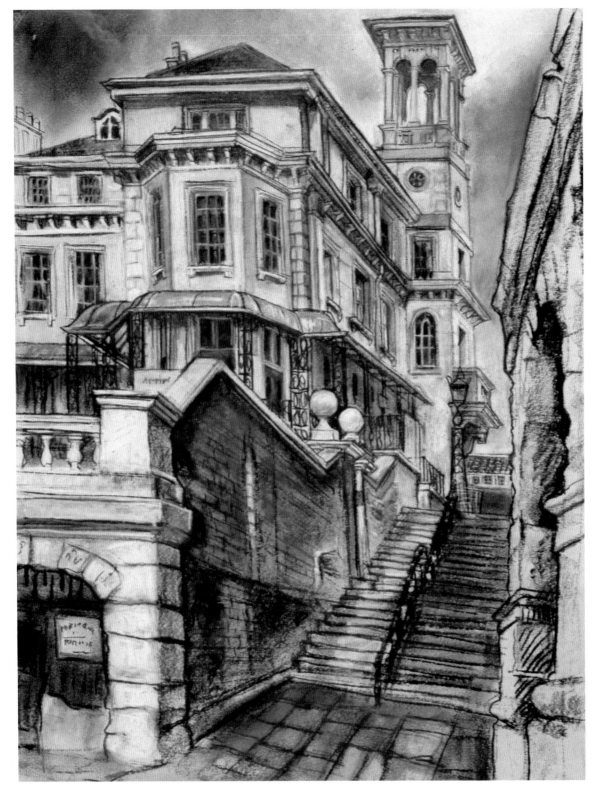

LEFT
Ginny Chalcraft
*Steps by Tower House,
Richmond*
Pastel, 14 × 21 inches (36 ×
54 cm)

RIGHT
Holding pencils parallel to
your face, and using only
one eye, line the pencils up
along each side of a
rectangular object going
away from you. Where the
pencils cross will coincide
with your eye-level and the
horizon, and establish the
vanishing point of that
rectangle.

and holding it, once again, at arm's length, keeping it parallel to your face and horizontal, line up the tip of the pencil with the side of one building. Slide your finger along the pencil until it coincides with the side of the other building, and you now have a measurement of the width of the shape. Keeping your finger firmly on the measured position on the pencil, turn the pencil vertical, line up with the bottom of the shape and see how many times your width measurement goes into the height. This rather fiddly process helps you to see and compare pro-

portion and scale. It is useful to take the initial measurement and compare it with other shapes and lines throughout the drawing, so as to maintain a constant check.

The other area to keep a constant check upon is the angles of lines and their relationship to each other. A line will only appear to be at an angle if it is relating to another line, be that the side of the drawing or a line within the drawing. Furthermore, if all the angles in a drawing are correct, the drawing will automatically be in proportion, so devising a way to check angles is very useful. A

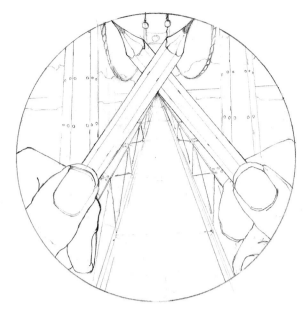

simple plumbline made from a piece of string, with a weight tied to the end, suspended from the side of the easel in such a way that it cuts through your view, will establish an absolute vertical with which you can compare other angles in the subject.

A less cumbersome, though less accurate, way to help you see angles, which I use, is simply to hold your pencil up and close to your face, in front of your eye, and align it along the line that you are investigating. The pencil becomes a huge line traveling at the given angle and emphasizes the angle, forcing you to see it (see illustration, page 51). If you are working at an easel, you can gently swing your body around to your drawing, while holding the pencil at the observed angle, and compare the measured angle with the corresponding line in the drawing, in order to make a rough check. It is surprising how easy it is to get the angles of lines going completely the wrong way, so a check is very useful.

All these measuring systems require you to look through one eye. This is because looking through one eye simplifies the information going to the brain, and having only one viewpoint tends to flatten the space. Looking through both eyes, we constantly compute the information from two sources so that our spatial sense is really very sophisticated. It is interesting that animals which have a crucial need to judge distance to survive, whether to leap from branch to branch or pounce on some unsuspecting prey, all have this binocular vision. When drawing, binocular vision tends to add confusion to the need to flatten real space into two dimensions, but the fact remains that we do have binocular vision and see the world in a more dynamic and

spatial way. While measuring systems are very useful to get a result, and help us see what we are looking at, they alone will not be able to generate the energy and excitement that you will engender when you embrace the full possibilities and problems of objective drawing.

Tone

Seeing the world in terms of shapes relating to each other, and gaining skills in drawing those shapes with line, gives a very strong basis for all drawing, painting and composition. Once you have observed the shapes, you can observe the effect of light on them, and develop the idea of form and space not just with line, but with light and dark, or tone. Tonal drawing relates much more directly to the way we see than does line. A line is a fairly abstract way of depicting the world; lines simply mark the boundaries of change where one area changes to another. Tone is what happens in these areas, so tone changes where lines in a drawing occur. Our eyes have evolved to respond to light and dark, and we perceive and understand our surroundings by decoding the information

BELOW
Kimm Stevens
Sketchbook
Pencil, 6 × 8 inches (15 × 20 cm)
This careful line drawing, done on a rainy day, explores the selective scale of objects over a distance. The stones on the wall are a comparable size to the more distant tower.

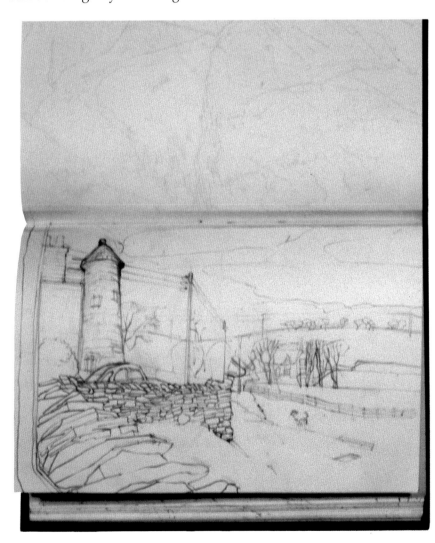

contained in the light and dark around us. We need both light and dark to do this. If we only have dark we see nothing (it's dark)! Conversely if everything is flooded with light from all directions, we again find it difficult to orientate ourselves. Ideally, we should have one really powerful light source, which casts light from one direction, thus illuminating one side of the form and casting a shadow on the other side. Fortunately, the landscape has one such light source: the sun.

Sunlight provides infinite variations of light, depending on the atmosphere and time of day and season. In the morning and evening, the sun is low in the sky and casts long, dramatic shadows; at noon, it is high in the sky and illuminates all round the form, casting less shadow and tending visually to flatten everything. If there is a lot of moisture in the air, the sunlight is diffused and loses its strong directional dynamic, softening all the tones. An extreme of this is fog, where the light is so diffused by water droplets that no tone reflected from any object can get through

directly to your eye and you see very little. The time of year also changes the quality of sunlight. In winter in the northern hemisphere, the sun is low in the sky and weaker and therefore casts longer shadows; colors are subdued. In summer, the sun is high and strong and we get bright colors and stronger shadows.

The height of the sun in the sky relates directly to the shadows cast. In the morning and evening, the sun casts long shadows which help to show form more directly and dramatically. The length of the shadow can be determined geometrically by projecting the angle of the sun to the horizon, through the object on to the ground beyond.

Sunlight not only casts shadows but illuminates the whole landscape, because it is diffused by the molecules in the atmosphere. On a bright day we are aware of a strong directional light, but less aware that most of the light has been diffused into a blanket of light that illuminates things more easily (on the moon, where there is no atmosphere, the sky is perpetually black and daylight only illuminates the rocks that it

FAR RIGHT
Kimm Stevens
Backyard II
Charcoal, 30 × 22 inches (77 × 56 cm)
This drawing exploits the contrast of black and white across the picture plane, sometimes referring to the light source, sometimes emphasizing the local color of the object. The result is an immediate, strong visual impact.

BELOW
Kimm Stevens
Barge
Charcoal, 22 × 30 inches (56 × 72 cm)
Taking a low eyelevel and drawing against the light emphasizes the scale and drama of the subject. Uncompromising use of black and white allows the medium its full range in order to achieve the luminosity required when drawing the direct light source.

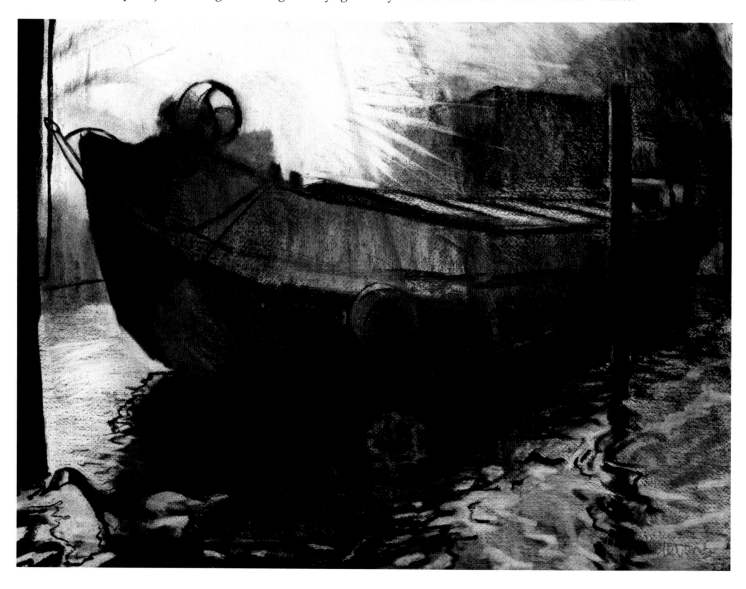

falls upon). This even blanket of light sets up another basic tonal relationship within the landscape. The sun, generally being above the landscape, casts more light on horizontal surfaces and less on vertical surfaces, so fields and roads and the land will often be lighter than the trees, hedges and buildings that stand upon it, regardless of their color. However, tops of trees and buildings will receive a similar level of light and will relate more to the horizontal land.

Just as in a line drawing, where space is shown by relating one shape to another, so a tonal drawing can only work if one area of tone relates to others right across the drawing. The lightest light that you have in drawing is the white paper, the darkest tone you can get is black, so you have to use these two extremes to create the relationships that exist between sunlight and landscape. You can only make an area bright and light by exploiting the darker ones which surround it. To help you see tonal differences, it is helpful to view the scene through half-closed eyes; this reduces the color and halftones and emphasizes the lightest and darkest areas.

In this chapter I have attempted to show various approaches to drawing, and how to use drawing as a means to greater understanding of the landscape. A systematic and measured approach to drawing enables you to understand and control the very complex problem of translating real space on to a two-dimensional plane. Understanding perspective, light and tone will allow you to anticipate certain natural events and phenomena as they occur. Drawing, however, is more than this. Once the basic elements and principles of the language have been absorbed – and I personally believe that this is essential if you want other people to

understand what you say – they provide a route for a rich exploration of media, composition and rhythm, which can provide the individual with a powerful means of expression. Drawing is an invaluable tool as well as a skill in its own right.

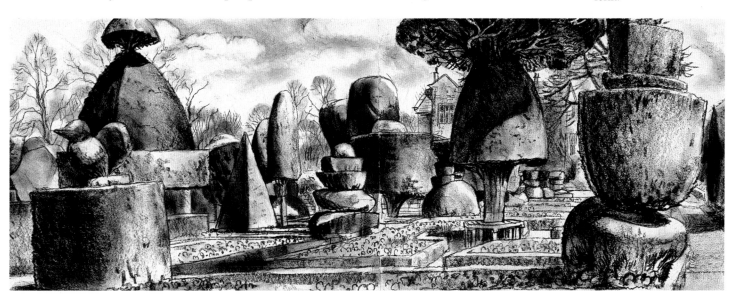

BELOW
Ginny Chalcraft
Topiary
Conté crayon, 11½ × 32½ inches (29 × 83 cm)
Here the light and dark relationships between trees and lawns create space and form.

4. Color

We now come to the most immediate and important element in landscape painting, color. Light plays an essential role in the way we see the world; in fact our eyes do not respond to objects, but to the light reflected off them. We do not see trees, grass, etc., but light that has bounced off these things and traveled into our eye. Sky is inevitably brighter than land, because the light has only been diffused by the air and is fairly complete. When the light hits a tree, a lot more of it is dispersed and absorbed by the tree, so that less bounces back and the tree appears darker. The passage of the light is broken and disturbed in many different ways, by being dispersed, reflected, absorbed, refracted and blocked, and this leads to the infinity of different conditions and effects that nature offers.

The Effect of Light on Objects

Newton demonstrated that light from the sun is made up of the colors of the rainbow, by splitting the white sunlight through a prism, slowing the rays at different rates through the different thicknesses of the glass, and then reassembling them to white light by passing them through another prism.

Different surfaces and textures reflect and respond to light in different ways. A mirror, for instance, reflects the rays of light so faithfully that we can see a complete image of where the light has come from, be it the light source, or other surfaces from which the light has reflected. A white surface is less reflective than a mirror and does not reflect individual images, but it does reflect a lot of light, most of it in fact, and white appears to be light. If you paint a room all white, especially if you include the floor, the room appears to be incredibly light. A piece of black velvet, however, appears to be very dark. A black surface, especially if its texture is not smooth, absorbs light, so appearing dark or black. If, on a sunny day, you feel the bodywork of a white car and a black car, you will find that the white car is cooler because the lighter color has reflected the light energy, whereas the black car has absorbed the light energy, which causes the surface to heat up.

The fact that different surfaces reflect or absorb light in different ways is crucial to gaining a full appreciation of the nature of color. A surface that appears to us as a parti-

BELOW
Clova Stuart-Hamilton
Dordogne Bathers
Watercolor, 12 × 16 inches (31 × 41 cm)
Figures emerge from the brushwork through the complementary warms of the skin tone reacting with the cool blues and greens of the surrounding landscape.

RIGHT
Kimm Stevens
Esher Common
Pastel, 21 × 30 inches (54 × 72 cm)
In this drawing the green-blue is exaggerated, to accommodate the intense red of the autumnal trees and to establish a certain distance by means of aerial perspective. The tree trunks form a grid in front of the color and establish a distance between the foreground and the powerfully red trees.

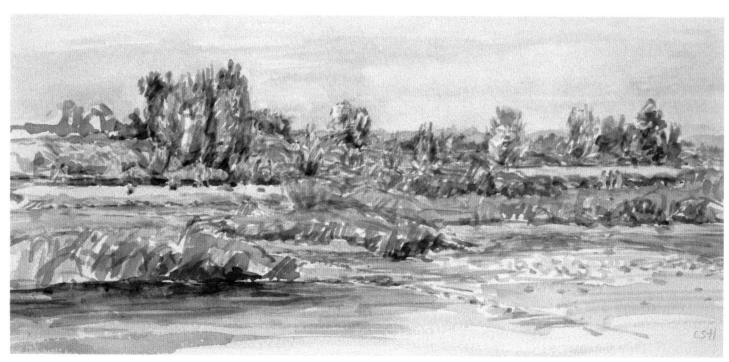

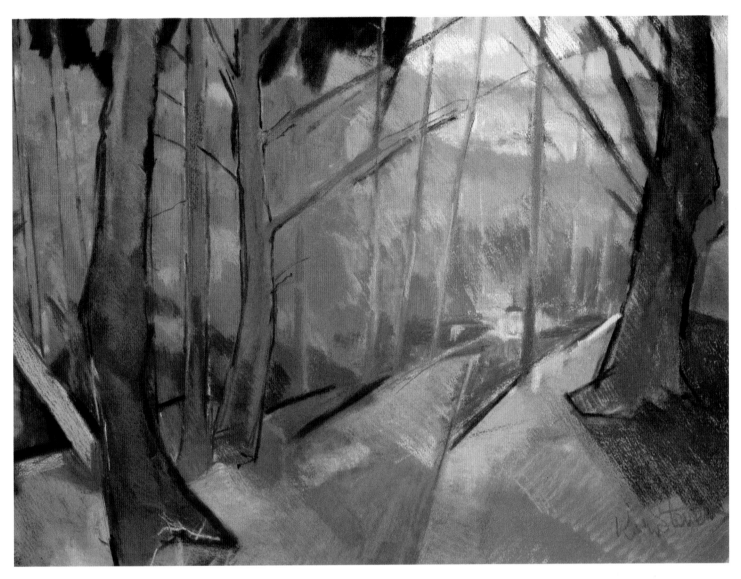

cular color does so by virtue of the fact that it reflects that color within the light spectrum and absorbs all the other colors. For instance, a red letterbox will reflect the reds in the spectrum that make up white light and absorb the blues, yellows and greens of the spectrum. A blue object will likewise reflect the blues and absorb the yellows, reds and oranges.

A close relationship develops between the light reflected by a colored surface and the light absorbed by that colored surface. In the case of the letterbox, red is reflected, and the mixture of blues, yellows and greens that are absorbed combine to give a green. There is thus a strong relationship of opposites between red and green, which are therefore said to be complementary to each other. If we look at the letterbox in a green light or through a green filter, there is no red in the spectrum of light that we are looking in, so none can be reflected back, but the red surface of the object still absorbs the green of the spectrum, and the object therefore appears to be black, as it absorbs all the available light.

Color and the Eye

Objects have a constant and close relationship with light, and their colors can change depending on the quality and quantity of light available. Our eyes also respond to light and color, and they are the other important factor in the way we perceive color. Just as objects reflect and absorb light, so the retina in the eye responds, compensates for and balances the levels of color and light that fall upon it. Generally, we see colors as they are; in normal conditions they are balanced and we accept the information conveyed by our eyes. If, however, we overstimulate the retina, strange things start to happen. Stare at a red spot for two to three minutes; in doing this you are overstimulating the red response in the retina. Now look away to a blank surface, or simply close your eyes, and you will 'see' a corresponding dot of a beautiful, luminous, greeny-blue, the perfect complementary of the red, because your eyes have been desensitized to red.

This same phenomenon often occurs when a strong color is close to a more neutral

BELOW
Look at the red spot for a few minutes, allowing your eyes to glaze over; the red spot will fluoresce and a halo will appear around it. Once this happens, look away to a neutral blank area, or simply close your eyes, and you will 'see' the complementary color, green.

or less reflective one. Take a bright green square and place in it a neutral gray square of a similar tone. After a short period of looking, the gray square will appear to be a plummy red. Using the same gray square, but with a blue border, the gray will appear to be slightly orange. Our eyes overcompensate in the more neutral areas and 'see' the complementary of the more dominant color, which is desensitizing the retina.

The Effects of Light on the Landscape

Light affects the way you see the landscape all the time, and once you are aware of this it opens up vast possibilities for painting. On a bright, hot, sunny day, the light is warm yellow and orange; it bounces off objects and sends back strong, hot colors to the eye. Where the light does not fall, the eye, over-stimulated by the hot colors, starts to see complementary cool colors in the more neutral, less luminous areas; the shadows appear to be blue and violet, the complementary of the warm yellow-orange light source. Obviously these colors are complicated by the local color of the object: a blue shadow cast on grass will become greeny blue as it mixes with the green of the grass. It

is very important to grasp the fact that a strong light sets up colors complementary to itself in the shadows, and it is well worth taking some time to observe and understand

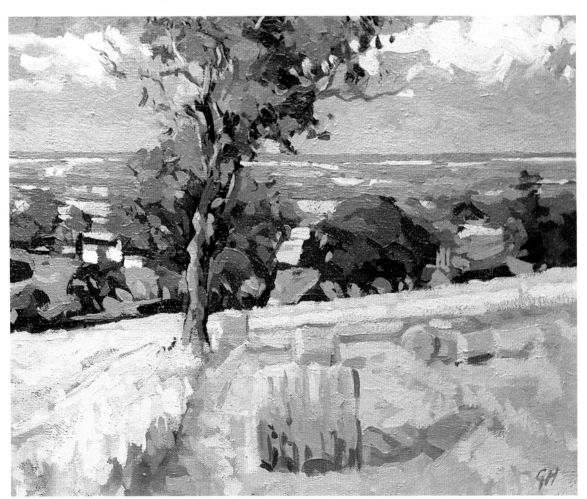

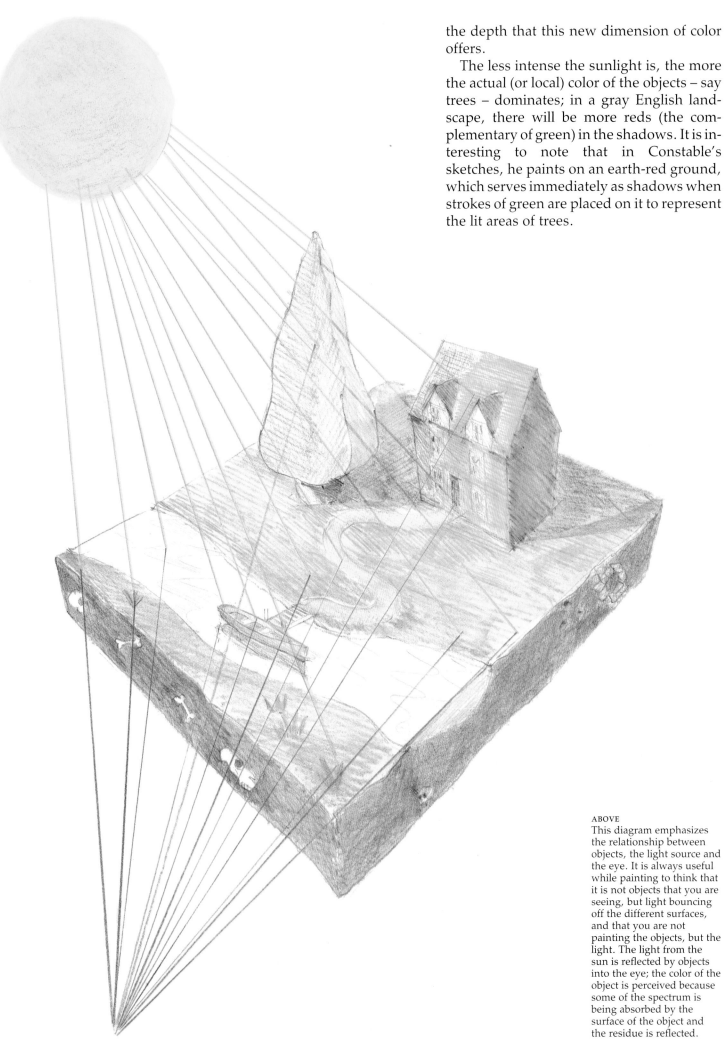

the depth that this new dimension of color offers.

The less intense the sunlight is, the more the actual (or local) color of the objects – say trees – dominates; in a gray English land-scape, there will be more reds (the complementary of green) in the shadows. It is interesting to note that in Constable's sketches, he paints on an earth-red ground, which serves immediately as shadows when strokes of green are placed on it to represent the lit areas of trees.

ABOVE
This diagram emphasizes the relationship between objects, the light source and the eye. It is always useful while painting to think that it is not objects that you are seeing, but light bouncing off the different surfaces, and that you are not painting the objects, but the light. The light from the sun is reflected by objects into the eye; the color of the object is perceived because some of the spectrum is being absorbed by the surface of the object and the residue is reflected.

Aerial Perspective

The other element of landscape which plays an important part in our perception of color is the atmosphere, which represents the vast bulk of any landscape. We usually relate to the terrain and any features which appear upon it, but these are mainly flat or undulating; the really big thing is the huge block of space that exists above the land. We usually refer to this as the 'sky', but this encourages a preconception of a blue plane with clouds dotted about. Try to see it rather as a volume, an entity in itself, albeit a gas rather than rock, which reacts with light in a different way to the more solid, tangible forms that it envelops. The solid forms reflect light; the atmosphere diffuses light, that is, light passes through it but gets redirected as it hits particles of moisture or pollution, which alters its quality and color. An extreme case of this is fog, where the light is so much dispersed by the particles of moisture that any light reflected off an object has been redirected many times, and we see very little of specific objects but rather a haze of white light. The same thing happens when looking over long distances; the further you look the more air and particles of moisture you look through, so the light is more diffused. The warmer slower-wavelength colors, reds and yellows, are dis-

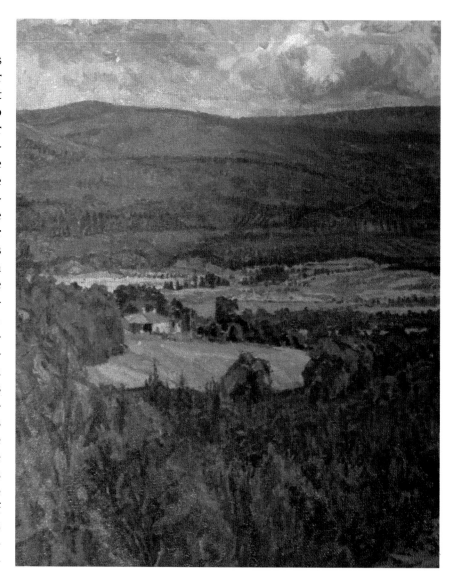

ABOVE
Clova Stuart-Hamilton
Valley of the Feugh,
Kincardineshire
Oil on canvas, 13 × 11 inches (33 × 28 cm)

LEFT
The actual color of the foliage and grass is the same in the immediate foreground and on the distant hills, but the effect of the atmosphere is to cool the almost yellow-green of the foreground down to blue and violet in the hills.

ABOVE RIGHT
Geoff Humphreys
From the Wolds
Oil on board, 16 × 18 inches (41 × 46 cm)
The distance in this painting is established, almost entirely, by the use of aerial perspective.

RIGHT
The sun is low in the sky and the light travels through a greater thickness of air to reach the eye, so that the lower frequencies, reds and oranges, dominate.

persed and it is only the higher-frequency colors, blues and violets, that get through, so distant hills appear to be violet and blue in contrast to the warmer colors in the foreground. This is known as aerial or atmospheric perspective and is why cool colors appear to recede and warm colors to advance.

When the sun goes down in the evening, the light has to travel through a greater distance of atmosphere and is slowed down. As a result the slower-frequency colors often dominate and in the evening the sky turns red and yellow. On damp autumnal evenings the effect is magnified by the moisture-laden atmosphere, which acts as a lens and makes the sun appear huge on the horizon.

Light and atmosphere play a huge part in the way we see the landscape. In terms of painting, it is the effect they have on color that is the key. Since shape and color are all that we have in painting, it is to color in painting that we now turn to link nature with landscape.

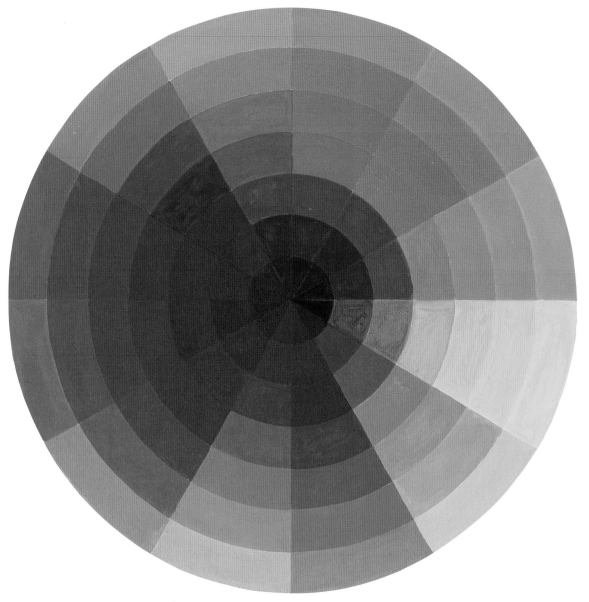

LEFT
It is very useful exercise actually to make this color wheel, as it forces you to mix colors carefully, using only a warm and cool version of the primaries red, yellow and blue. Construct a circle with a radius of 7 inches (18 cm) on a piece of card. Draw six concentric circles at 1 inch (3 cm) intervals toward the center, and then draw radii at 30 degrees to each other from the center, thus producing the twelve segments. The mid-ring is pure saturated color, the outer rings are progressively lighter tints, and the inner rings are the darker tones, which are best achieved by adding carefully judged complementary color in order to absorb the light down to black (NB no actual black was used on this color wheel). The wheel demonstrates the relationships between the complementaries, the cool blue, green, purple opposing the warm orange, red and yellow, and the different tones and tonal ranges of the colors, e.g. yellow is light, blue is dark. Note also how much of the color wheel is green, from the yellow segment right round to the blue segment, a good third of the whole wheel, hence the subtlety of that color.

RIGHT ABOVE
Geoff Humphreys
Green Fields
Oil on board, 14 × 18 inches (36 × 46 cm)

RIGHT BELOW
This diagram demonstrates the varying tonal ranges of four basic colors. The green and blue operate as color from white right through to black, whereas yellow can only be described as yellow from white down to mid-tone yellow; as soon as any dark is added, it becomes brown, and yellow therefore has a limited tonal range. Red is even more restricted tonally, only operating as red in the mid-tone range. If you paint in the tone band that accommodates all the colors, the red will be less likely to 'jump'. To achieve a light red, the colors around it are adjusted to a darker tone.

Color Wheel

Just as colors affect each other in nature, so they do in painting. Once again it is all to do with relationships. A red shape painted on a white ground appears to be dark, while the same red shape on a black ground will appear to be light. It is the relationship of one color to those surrounding it that conveys the idea and intention of the painting. The difference between color in nature and color in painting is that, in nature, when the colors in light identified by Newton are mixed they become white light, but when pigments are all mixed together, as you will soon discover, they become a sludgy, browny-black, because the pigments absorb light. Adding white lightens color, but reduces its intensity. Thus working with pigment has its limitations, which need to be understood in order for color to be used to its maximum effect.

When you are painting there are two color dynamics to work with, light and dark colors, and warm and cool colors. It is very useful at this point to construct a color wheel, where the relationships between colors and their complementaries can be observed. In the color wheel illustrated here, the tonal dynamic, white to black, is integrated with the saturated color dynamic of complementaries and warm and cool. It is important to note that the black center in the darker versions of the colors is achieved by adding carefully judged complementary 'absorbing' colors. These cancel out the reflective color and produce darker versions of the color, until a point of no reflection, or black, is reached in the center. White is added in stages to the original saturated color to produce the lighter tones or tints.

In making the color wheel, you will be able to observe, first, that different saturated colors are of different tones (pure yellow, for instance, is lighter than pure blue); and, second, that colors respond tonally in different ways. Blue still remains blue even when it is very light and when it is very dark;

it remains the same color throughout the tonal range. Red, however, behaves differently; when it gets dark it becomes brown, and when white is added, it becomes pink. Pure red has a very limited mid-tone range. Likewise, yellow operates as yellow when it is mixed with white, but in the darker sections it goes brown and loses its hue, or pure color. Yellow also has a limited tonal range. This limitation on the warm colors, red, orange and yellow, means that they have to be used with some care to balance their tones with the surrounding colors.

If you are painting a red object in the landscape, the surrounding colors have to be adjusted to the required tonal level of the local red color. Otherwise the tonal structure of the painting will be disrupted and the illusion of space destroyed, with the red object appearing to jump out of the picture because the contrast is so great. This is, of course, why the color red stands out in real life; it has such contrast. A true red has a mid to dark tone, which stands out against the generally lighter tones of the landscape. Combined with the fact that the color of the landscape is often green, the complementary of red, this doubles the potential impact and problem of red.

Orange and yellow have similar properties, but because they have a broader tonal range, up to white, they are slightly more flexible and can be balanced more easily. This is one of the main reasons why paintings with flowers in bloom often go very flat; the artist has not recognized and maintained the tonal balance between the hot colored flowers and the green shadowy leaves, and the flowers jump forward, destroying the illusion of space. Of course in nature that is just what the flowers are meant to do, standing out from the foliage in order to attract bees and other insects. It is thus very difficult to maintain the illusion of space, by balancing the tones of the picture according to the light source and then allowing enough color contrast, in order to show the brightness and beauty of the flowers, while still holding them in their place within the illusion of the picture.

The other major problem that landscape painting poses is the use of the color green. If you have any sense at all, you will at this point close the book and take up embroidery, but if not, take your color wheel and observe the fact that the area covered by green extends from the yellow segment through green right round to blue and

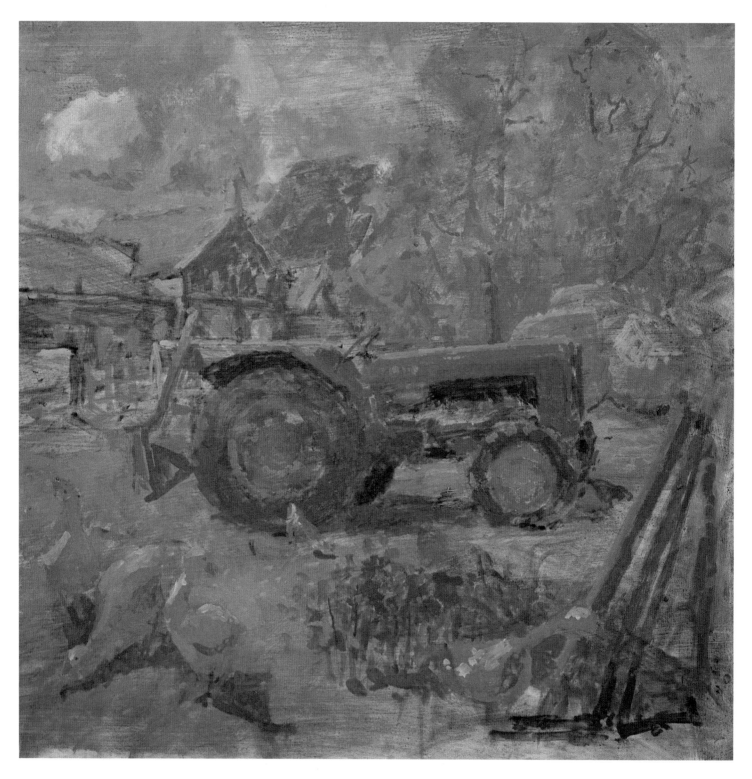

ABOVE
Peter Lloyd-Jones
Fordson Major
Oil on canvas, 36 × 40
inches (92 × 102 cm)
A good example of holding
red in place by exploiting
the complementary blue-
green in the bodywork of
the tractor and the
surrounding landscape.

through all the concentric segments from white to black. There are yellow greens, olive greens, bluey greens, and many, many more. In fact, both a cool yellow and a cool blue will appear to be green when placed next to a warmer color. Green has a huge color and tonal range, which must be encompassed in order to grasp the full potential of the color. Look at the landscape not as being green, but as having different levels of yellowness or blueness. Take a small piece of card, about 2″×3″ and punch a small hole in the center, about ¼″ diameter, then select a tree in the middle distance and observe its color through the hole; you have isolated

that color. Bring the hole down to a green in the immediate foreground, say the grass at your feet, and observe the difference between the greens; the tree is probably a lot more blue than the grass. These differences can then be exploited in the painting. Even if they are exaggerated, tree shown as blue and grass yellow, the relationship will still work and the illusion of space will exist.

Color Mixing

We turn to the color wheel once again when mixing colors on the palette. Red, yellow and blue are the primary colors, essential for

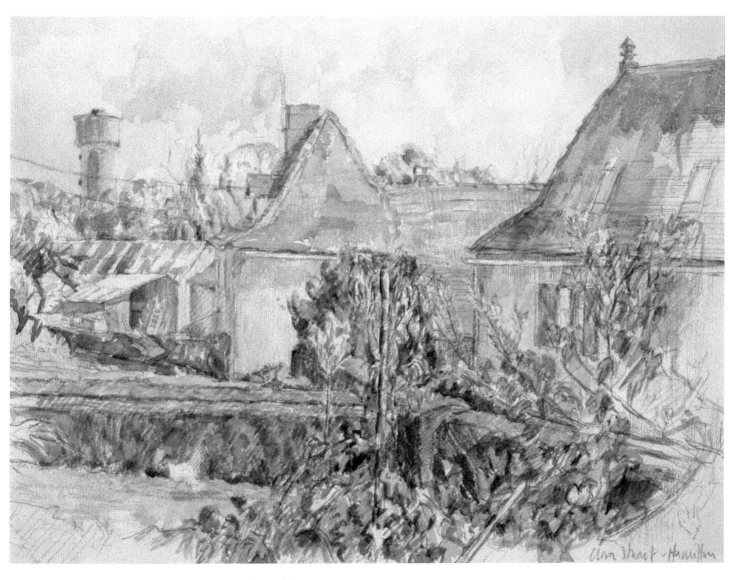

ABOVE
Clova Stuart-Hamilton
Houses at Born
Watercolor, 13 × 16 inches
(33 × 41 cm)

LEFT
Kimm Stevens
Tree
Oil on board, 9 × 12 inches
(23 × 30 cm)

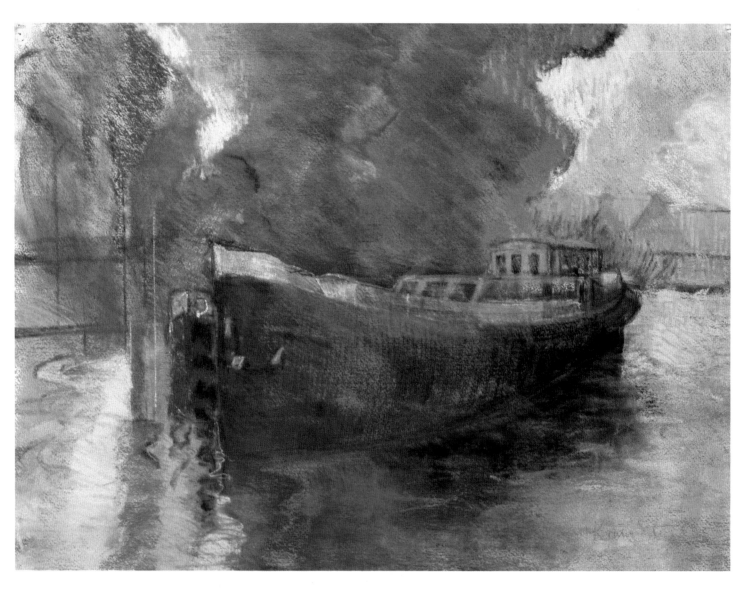

mixing all the other colors. Mixing any two primaries produces the secondary colors:

Orange – Red plus Yellow
Green – Yellow plus Blue
Purple – Blue plus Red.

If the third primary is added (which is the complementary of the secondary color), it will absorb the initial color and tend to make it darker and less saturated. If blue is added to its complementary, orange, it will produce dull, darker orange or brown. Add more blue, and it will become cooler and grayer. Add white to the mixture, and a full tonal range of grays, beiges and browns becomes possible.

Once you have absorbed the initial idea that any color can be mixed by balancing the three primaries and white, and that the pigments both reflect and absorb light, so a color that is too bright can be altered by adding its complementary (or its light absorber), you can calculate the mixing of colors quite accurately. Black, as we have seen, is a total light absorber and is much more powerful than any other color, so it not only cancels out the complementary but makes

the whole mix duller and less reflective, and should be avoided when mixing color.

This method of color mixing relies on the absorption and reflection of light and leads to a fairly subdued use of color, because the pigments ultimately all mix together to produce black, absorbing the light that hits them. This is known as **subtractive mixing**. Another way of mixing colors is to place small dots of pure color next to each other, so that the individual colors remain as bright and as intense as possible but, when seen from a distance, merge and reveal the image in color and tone. For instance, a pale blue sky could be made up of blue dots and white dots. A tree in front could be more blue dots and green dots, or it could be blue dots and yellow dots, which would then at a distance merge to become green.

This is known as **additive mixing** and painting in this manner operates in two ways. Firstly, it produces a more luminous effect, because it works by mixing the reflected light rather than reflecting the mixed pigment. Instead of tending toward black, as does subtractive mixing, additive mixing

ABOVE
Kimm Stevens
Barge with Tree
Pastel, 21 × 30 inches (54 × 77 cm)
By linking the near barge and the distant tree, the surface of the picture dominates and one is aware of the shape before the object. The cold green finally forces the tree into the background.

RIGHT AND ABOVE RIGHT
Kimm Stevens
River Wey
Pastel, 22 × 30 inches (57 × 77 cm)
This series shows the combined use of watercolor sketch and photograph to produce a studio pastel. The watercolor is essential in conveying the essence of the scene, the photograph provides the facts of proportion and captures the shafts of sunlight between the trees. These are then combined in the studio to produce the final piece, which concentrates on achieving luminosity and light through harmonies between warm and cool blues, greens and grays.

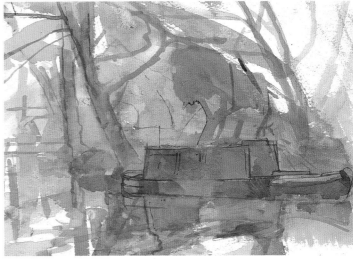

tends toward white because all the colors of the light spectrum mix together to produce white light. Secondly, it allows the painting to relate to itself across the whole surface. A blue dot in the sky will relate visually to a similar blue which is part of a tree. The sky may be made gray by adding complementary oranges and reds which, in turn, may relate to the reds of buildings or pathways. Thus the eye can be led across the surface of the painting, without any one element becoming separated from the whole image. This method of painting was exploited in the landscape by the Impressionists, and especially by Camille Pissarro, who often painted with firm dashes of color right across the canvas, filling shadows with blues and reds and linking sky and land with blues, greens and whites. It was developed and formulated by Georges Seurat into the technique

ABOVE LEFT
Barge photograph.

ABOVE RIGHT
Barge sketch.

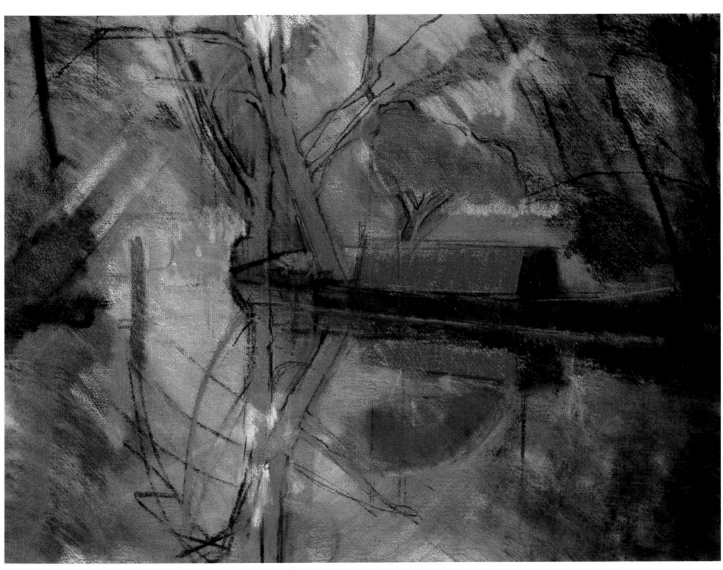

Bushy Park

Bushy Park

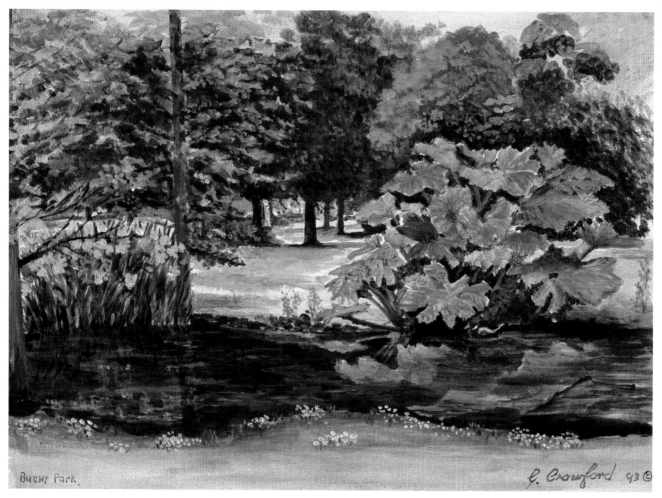

Bushy Park.

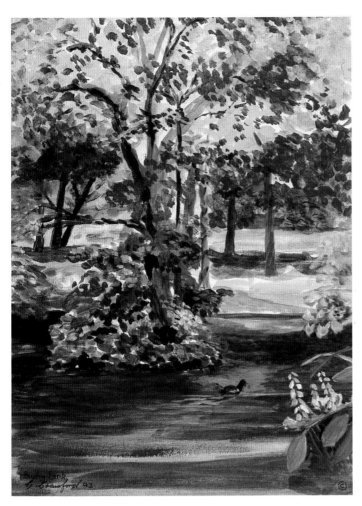

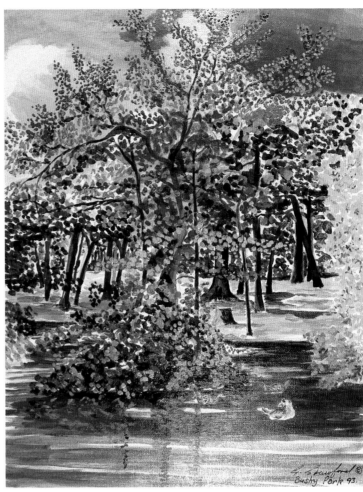

known as the Divisionist, and later the Pointillist, style of painting.

The third method of color mixing is by the use of **glazes**. This is of paramount importance in watercolor painting, but is also useful in acrylic and oil painting. A glaze is basically a thin transparent layer of pigment, which allows the color of the surface underneath to show through. In watercolor painting, the white paper is often used as the light source and tones are established by laying in carefully planned areas of color, which themselves maintain a luminosity by being thin enough for the white still to shine through. Different colors can be achieved by glazing one pure color over another; for instance, one green can be made by laying yellow over blue, a different green by laying blue over yellow! A glaze of red over its complementary, green, will produce brown or darker tones. Colors can be cooled down or warmed up by delicate applications of blues or reds. Warm or cool versions of primary colors will produce very different secondary colors. Glazing is an extremely subtle and delightful way of painting, but requires disciplined decisions based on drawing to prevent the subject from becoming vague and woolly.

In oil painting, glazes are prepared by mixing paint with linseed oil and a little turpentine, which thins the color down but retains a certain amount of body to the paint. Glazes should be applied by a soft brush with the painting laid flat, and must be allowed to dry before further layers are applied. Glazing was used extensively in oil painting up until the mid-nineteenth century, when the Impressionists abandoned it in favor of a more direct application of color. Glazing offers many delicate and subtle effects, however, and the method should be explored and exploited. A very practical use of an oil glaze, to help revitalize a painting, is to rub into the dry painting a thin glaze of Prussian Blue. This reduces the color and heightens the tones, which reinforces the basic form and structure of the picture. The painting can then continue working into the wet glaze, which has a gentle, softening effect on the paint.

Color is a ludicrously complex issue in painting. I have tried to explain some basic theories and their direct practical use. I have not touched on the equally important emotional or symbolic uses of color, because an objective approach is initially more appropriate in landscape painting, and provides a basis from which to develop interpretation and expression.

George Crawford
Landscape painting series
Acrylic on paper
This series of paintings was made over a period of ten weeks by one of my students. It lucidly demonstrates a growing understanding of the dynamics that exist between color and tone. The first painting (far left top) is predominantly green, but there is little evidence of the light source and its effect on form and color. This results in a fairly flat image. As the series develops, the student becomes more confident with color and experiments with extending the range of green into blues and yellows; the tone and color relationships become more dynamic and the sense of space and volume is enhanced. By the final painting (above), the landscape is depicted almost entirely through color. Separate areas of the landscape, e.g. blue sky, green land, are now integrated, as the eye relates blues in the shadows to blues in the sky, reds in the branches to pinks in the sky, thus consolidating both the picture surface and the illusion.

5. Composition

Composition embraces all the techniques and theories of painting that we have discussed, and brings them to life. It is the very basis of expression and the vehicle through which the artist conveys his or her ideas. At its most basic level, composition is the arrangement of shapes and lines on a surface which makes up the picture. In terms of landscape it is where key elements, like the horizon, trees and buildings, are placed on the canvas to make an arrangement.

How various elements are placed on the canvas is surprisingly important, because we are dealing with a two-dimensional illusion of space. Things which in real life we can accept as being distant from each other suddenly develop very powerful visual relationships when translated into two dimensions. A classic example of this is the wedding photograph, where the photographer fails to take into account the background and the bridegroom has a telegraph pole sticking out of the top of his head. Now this inadvertent 'mistake' illustrates a fundamental property of painting and composition: that, while dealing with an illusion of the three-dimensional world, we are in fact working upon a flat surface which has its own geometry and sets up its own relationships beyond mere illusion. Perhaps the

LEFT
Joe McGillivray
Birkenhead Docks II
Mixed media, 43 × 63 inches (110 × 161 cm)
Here realism is secondary to the pattern and weight offered by the shapes inherent in an industrial landscape.

TOP RIGHT
The position of the vertical axis helps define space: centrally it emphasizes symmetry and flatness; placed to the left or right it creates a feeling of space and movement, the eye being given a contrast of size in the division of the basic rectangle.

BELOW FAR LEFT
Symmetry. Vertically the image appears flat; horizontally it can be read as a reflected landscape.

BELOW
The different horizon heights create a different feeling of space; the space is symmetrically even (far left); the large sky appears very spacious (center); the land dominates and creates a more oppressive feeling (below).

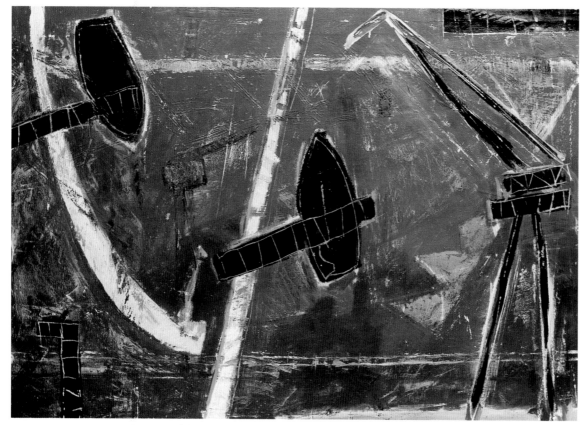

classic mistake dreaded by wedding photographers is, ironically, the key to the true excitement and power that is inherent in composition. We must always be aware of the flat relationships between shapes across the canvas as we build the illusion of space.

Dividing the Picture Surface

Within composition, there are various possible basic divisions of the canvas. There is the very powerful device of symmetry, which tends to flatten and emphasize the two-dimensional surface and is used for decorative effects. In landscape it exists in reflections and is useful for linking one area to another. Dividing the canvas evenly, with a horizontal and vertical line, will emphasize flatness. Taking the horizontal line as a horizon, and placing it higher or lower than the center, creates a different feeling and begins to suggest an implication of space. Placing the vertical axis off-center increases this sense of space. Because the horizontal and vertical axes are parallel to the sides of the rectangle, they are always closely related to it and tend to emphasize flatness. If we introduce a more contrasting diagonal, the illusion of space becomes more powerful, because of the contrasting dynamic and the implied possibility of perspective. Separating some lines from the edges and corners of the canvas further strengthens this illusion.

Square of the Rectangle

The rectangle of the canvas itself plays an important role; your eye and brain are constantly comparing the shorter dimension to

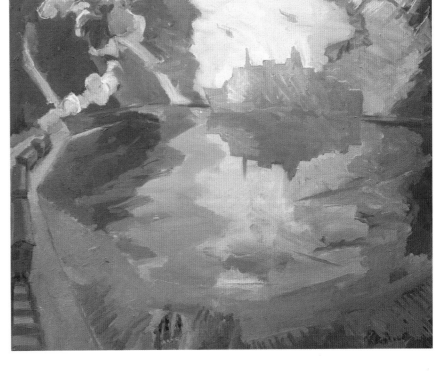

the longer, so a relationship can be developed and emphasized along the division created by the shorter on the longer side, producing a powerful position within the canvas. This is known as the square of the rectangle and can be projected from both sides. If you find the squares of the rectangle in an Old Master painting, it is amazing how many crucial and important things occur on those lines.

Golden Section

Another very useful division of the painting to be aware of is the Golden Section. This is a harmonious division of a line, where the ratio between the longer section and the total length of the line is the same as that be-

ABOVE
Kimm Stevens
Day by the Sea
Oil on canvas, 36 × 48 inches (92 × 123 cm)
Changes in scale and a high viewpoint create emotional tension.

BELOW
Diagonals create much more active movement within a composition: placed centrally and symmetrically (far left) produces an effect of greater flatness; placed obliquely high or low, or to the left or right, produces movement and space.

tween the shorter section and the longer section. Because each length relates in some way to the other, a perpetual harmony and balance is obtained which is visually very satisfying. The golden section of a line can be found by following the simple steps illustrated. Once the line has been divided, the longer section can be projected vertically to construct a rectangle in the golden section. This adds to the glory of it all, because now the square of the rectangle is also on the golden section, which produces even more powerful relationships and coincidences. The remaining rectangle is itself, once again, in the golden section, which can be squared once more to produce an even smaller rectangle on the golden section. You can go on forever producing smaller and smaller harmonious divisions of the rectangle.

Now if you plot a diagonal through all the squares, you should obtain a spiral, a beautiful, organic, natural growth form, perhaps a clue as to why the golden section seems to us natural and organic, somehow 'right' and satisfying. When a painting feels 'right', it is often because these more mathematical divisions have been instinctively satisfied. So don't panic and construct everything in the golden section, but be aware of the possibil-

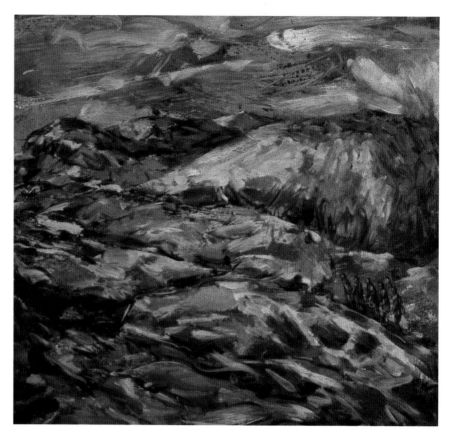

ities offered by these factors while you paint and, if the painting does not feel right, try positioning some important elements in the composition on these lines and see if things

ABOVE
Conor McFeely
Mountain Pass
Oil on board, 36 × 36
inches (92 × 92 cm)

LEFT
Geoff Humphries
Railway Embankment
Oil on board, 16 × 18 inches
(41 × 46 cm)
Another powerful use of
the diagonal in a
composition.

ABOVE RIGHT
Step diagram to divide a
line in the golden section.

RIGHT
Step diagram to form a
rectangle in the golden
section.

Take a given line, say the length of the base of a painting.

Divide in half.

Project the half measurement vertically from one end.

Draw a line to form a triangle.

Extend the half measurement of the original line down the hypotenuse of the triangle.

Using a compass, project remainder of hypotenuse down to the base line: this point divides the line in the golden ratio.

Decide on the shorter length of a rectangle for a painting and construct a square whose sides are this length.

Draw a diagonal from the center point to the top right corner; project the length of the diagonal down to the base line.

Construct a rectangle extended from the square; it is in the golden ratio.

Project the short side of the smaller rectangle on to its longer side; this gives the square of that rectangle, also in the golden ratio.

The original rectangle is now divided in the golden section.

This section can be repeated from the other two sides to create four points within the rectangle, all on the golden section.

Continue finding the square of the ever decreasing rectangles.

Drawing a curve, using the side of each diminishing square as a radius, produces a spiral.

Constructing the square of a rectangle by projecting the shorter onto the longer side.

This can be done from both sides.

start to fall into place. The golden section can be constructed from both sides, and obviously from the vertical as well as the horizontal sides, of the rectangle. Once again, it is extremely revealing to construct these lines on a postcard of an Old Master painting, just to see how much use is made of them.

So far we have divided the picture composition up with basic straight lines, which are very powerful because they relate directly to the edges of the canvas, help link one side visually with another, and project the composition right across the surface. They guide the eye across the picture and gently direct the viewer around the image in the way that you, the artist, want. This gives you great power to create different moods and forms of expression, depending on how you devise your picture, which is really what composition is all about.

There are, however, many other ways to guide the eye around the picture. Lines that repeat are linked by the eye, so a row of poplar trees sets up a rhythmic pattern that the eye will respond to. Reflections of sky and trees in water again set up a visual link and rhythm. By establishing a visual rhythm, say of poplar trees, you can speed up or slow down the eye's journey across the picture space, by varying the intervals or spaces between the trees.

ABOVE
Peter Lloyd-Jones
Coombe Lake
Oil on board, 14 × 14 inches (36 × 36 cm)
The repeated rhythm of reflected trees carries the eye across the canvas.

ABOVE RIGHT
Ginny Chalcraft
Wapping
Watercolor and colored pencil, 10¼ × 20 inches (26 × 51 cm)
Composition as a collage.

RIGHT
Geoff Humphries
Tree
Oil on board, 18 × 24 inches (46 × 61 cm)
Strong use of curves and circles.

If the eye is guided by graceful swirling curves, it travels in a more flowing way, producing a gentler, slower image. The position of the main elements of the image on the canvas is also very important. If they are placed toward the top of the canvas they have a potential energy; there is a suggestion that they may fall down the surface, they are in tension and are dynamic. If they are placed along the bottom of the image, they have landed and expended their energy and appear to be more tranquil.

This, in landscape painting, often relates to the level of the horizon. A low horizon allows for large expansive, spatial skies; a high horizon suggests land piling up into a claustrophobic density of overwhelming power and scale. If the image is cut by the sides of the canvas it appears to be dramatically close to the viewer, which creates a powerful sense of movement in the canvas. This device must be used with great care as the nearness produces a very dramatic change in scale, though it can be highly spectacular if used well.

Composition and Tone

These linear elements of composition operate in tone as well. For instance, a strong light source will emphasize form and give a constant directional movement across the image. Shadows automatically repeat their objects visually and, at the same time, they subtly distort them, depending on how the light source is placed. A strong positive light source is also very useful in maintaining an interesting level of contrast, that is an effective balance between dark areas and light areas. If there is too much light, the picture may appear bland; too much dark and it may appear dull. It is often a good idea to identify an area that is totally dark and one that is pure white, and operate the tonal range of the picture between these two extremes, thus ensuring you are using the total tonal range available to you.

One of the major tonal problems in landscape is that the composition can so easily fall into two halves, the light sky meeting the darker land. On occasion this simple relationship can be quite elegant, and the composition can exploit this fact as long as the division is carefully considered. There are, however, limitations to this form of composition, and a far richer approach is to find similarities of tone between the sky and the land, thus linking them visually.

Water is a very useful feature which re-

flects the sky, thus bringing the tone of the sky down into the land. Similarly, clouds in the sky break the light and cast shadows, which may make the sky as dark as the lighter parts of the landscape, thus making it more complex and interesting, and linking it with the land. Vertical features such as buildings, trees and hills have a different tonality to the horizontal plain of the landscape, so can be used to cut across the horizon and link the tones of the sky and the land with a third tone.

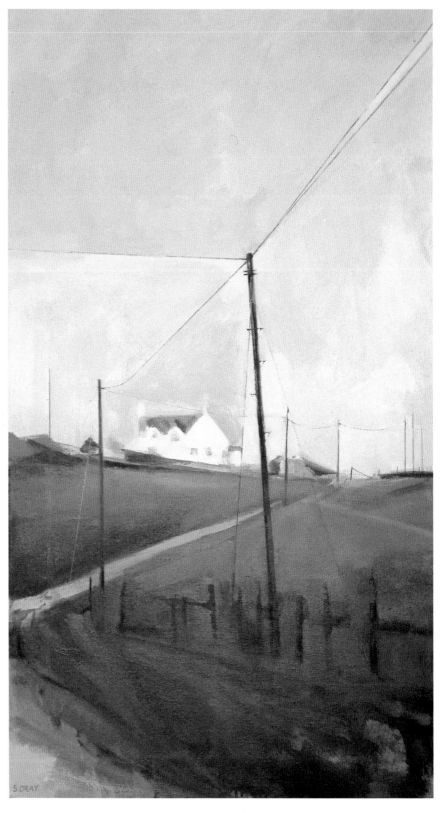

ABOVE
Sally Dray
Iona
Oil, 40×20 inches (102×51 cm)
The segments of sky echo the landscape below.

RIGHT ABOVE
Kimm Stevens
Snow Barge
Pastel, 22×36 inches (56×92 cm)
Here the dimensions are in the golden ratio.

RIGHT
Joe McGillivray
Birkenhead Docks I
Oil, 48×60 inches (123×154 cm)

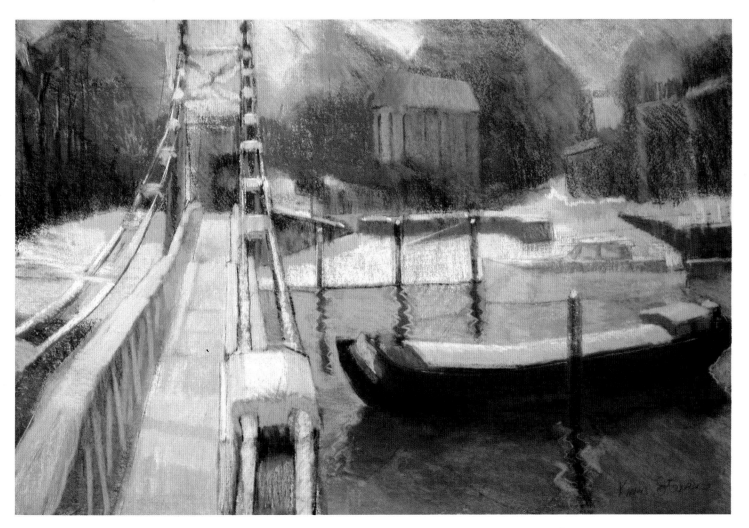

By carefully considering all these possibilities, composition ideas can be developed as you paint the landscape. A painting becomes a process of finding the best way to show what you are looking at, in terms of creating an interesting and flowing composition on the canvas. Thus cloud shapes may echo darker tree shapes, both of which have been reflected in a lake. Your eye is fed simultaneously with reflections, echoed shapes and contrasts, which combine to make a composition.

Composition and Color

Like tone, color plays an important role in composition. We have seen how the eye responds to color, constantly linking similar colors yet also relating complementaries to each other. The tonal problem of the light sky meeting the dark land can be resolved in terms of color, by finding similar colors in both land and sky and thus counteracting the contrast through color, while allowing the tonal difference to remain. So a yellow in the sky will immediately relate to a yellow in the land; they may be different tones and temperatures, but they will still bridge the divide ceated by the tonal difference.

Making use of complementaries is also an important compositional idea. A neutral-colored road or track running through green fields will take on the complementary, red. Make use of the contrast, maybe exaggerate it a little, to create a color dynamic in the composition. Trees that cut vertically across the sky and the land can change color radically as their relationships to the sky and the

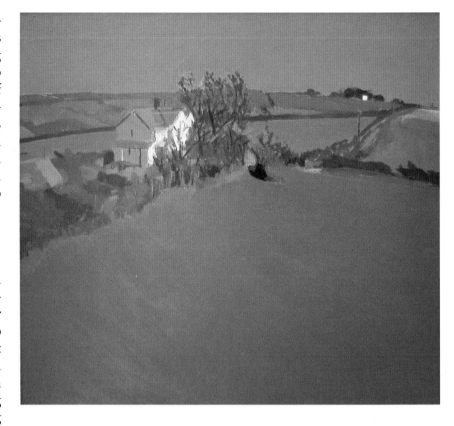

ABOVE
Jim Lee
House in Cornwall
Oil on board, 12 × 11 inches
(31 × 28 cm)
A very high horizon gives space and energy to the distant focal point of the bright house.

LEFT
Kimm Stevens
In Suburbia
Oil on canvas, 48 × 60 inches (123 × 154 cm)
Taking an unusual viewpoint, and simplifying basic elements that make up the artist's local landscape, enables the painting to convey messages and images beyond the objective.

RIGHT
Kimm Stevens
Backyard with Flying Panda
Charcoal, 30 × 22 inches
(77 × 56 cm)

ABOVE
Kimm Stevens
The Garden
Oil on canvas, 30 × 40
inches (77 × 102 cm)
By taking a low viewpoint,
the artist creates a feeling of
tension and menace, which
is exacerbated by the long
shadows cast by the house
and children.

LEFT
Conor McFeely
Donegal
Oil on board, 36 × 42
inches (92 × 107 cm)
Both of McFeely's paintings
(see also page 70) show
radical use of paint and
color to express the feeling
of the landscape, rather
than to represent it. Much
control is needed, however,
to convey the image
through such an expressive
method.

LEFT
Ginny Chalcraft
Docklands
Watercolor and colored
pencil, 9¼ × 15 inches (24
× 38 cm)

land alter, so the base of the tree may be warm and light while the top may be cool and dark. Again, look for these reactions and exploit and emphasize them.

All these ideas are possibilities that one should look for and think about while painting in the landscape. The more painting you do, the more ideas you will have about how to develop interesting and successful compositions. There are no hard and fast rules that must be obeyed, but there are certain divisions and contrasts that are powerful and are well worth being aware of as you paint. In the end the only really crucial criterion for a good composition is that it does what you want it to do.

Composition is a tool of infinite subtlety, to be used by the artist to convey ideas and feelings of what he or she is painting. So the ultimate question you should ask yourself is: Why am I here? What is it that I personally like or feel about this place? and: How on earth am I going to show this unique excitement to other people with my painting?

BELOW
Phillipa Clayden
Cornish Walkabout
Mixed media and collage on
board, 84 × 150 inches (215
× 384 cm)
By combining different
materials and images, the
imagination is triggered
and stimulated into
fantastic journeys.

Index

ACKNOWLEDGMENTS

The publisher would like to
thank designer David Eldred,
indexer Helen Jarvis,
production controler Susan
Brown and editor Jessica
Hodge. We would also like to
thank the following
institutions, agencies and
individuals for permission to
reproduce photographic
material.

Chalcraft, Ginny: pages 29
(above), 44 (below), 47 (below),
49 (above), 50, 53 (below), 73
(above), 79 (below)
Clayden, Philippa: page 79
(below)
Dray, Sally: pages 36 (both), 74,
76 (below)
Humphreys, Geoff: pages 34
(below), 35 (below), 41 (below),
56 (below), 59 (below), 60
(above), 70 (below)
Kröller-Müller Museum,
Otterlo: page 21
Lee, Jim: pages 43 (below), 76
(above)
Lloyd-Jones, Peter: pages 1, 62,
72
McFeely, Conor: pages 70
(above), 78 (below)
McGillivray, Joe: pages 68, 75
(below)
Musée Fabre, Montpellier: page
19
Musée d'Orsay, Paris, photo
courtesy Réunion des musées
nationaux: pages 16-17, 24-25
National Gallery, London:
pages 6, 7, 8-9, 10-11, 12-13, 14,
20
National Gallery of Scotland,
Edinburgh: page 18
National Museum of Wales,
Cardiff: pages 22-23
Stuart-Hamilton, Clova: pages
28 (below), 44 (above), 54, 58
(above), 63 (above)
Tate Gallery, London: page 15
(below)
By courtesy of the Board of
Trustees of the Victoria and
Albert Museum, London: page
15 (above)